Sister Wendy's AMERICAN Masterpieces

Sister Wendy's
AMERICAN
Masterpieces

Sister Wendy Beckett
Contributing Consultant Patricia Wright

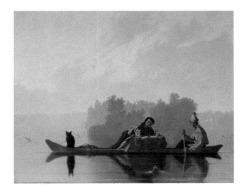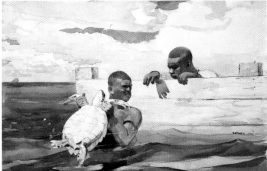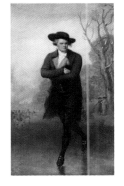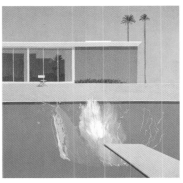

A Dorling Kindersley Book

DK

LONDON, NEW YORK, SYDNEY, DELHI, PARIS,
MUNICH, and JOHANNESBURG

Senior editor Louise Candlish
Senior art editor Heather M^cCarry
Editor Susannah Steel
Art editor Claire Legemah
US editor Barbara Minton
Senior managing editor Anna Kruger
Managing editor Steve Knowlden
Deputy art director Tina Vaughan
Production controller Sarah Coltman
Picture researcher Marianna Sonnenberg

*I would like to dedicate this book to Tricia Wright, without whose support,
research, insights, and inspiration, it would never have been begun;
let alone finished. Thank you dear Tricia, invaluable friend.*

First UK Edition, 2001
00 01 02 03 04 05 10 9 8 7 6 5 4 3 2 1

Published in Great Britain in 2001 by Dorling Kindersley Limited
9 Henrietta Street, London WC2E 8PS

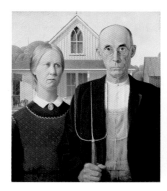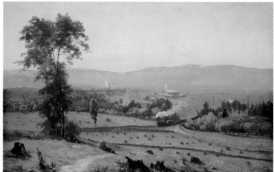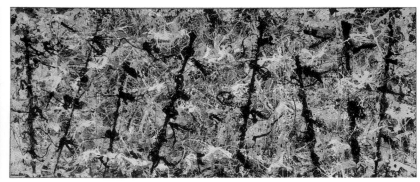

A CIP catalogue record of this book is available from the British Library.

0–7513–2772–7

Colour reproduced by GRB Editrice, Italy
Printed and bound by A.G.T., Spain
D.L.TO: 321-2001

See our complete
catalogue at
www.dk.com

CONTENTS

ALBERS, JOSEF 1888–1976 b. Germany

STUDY FOR HOMAGE TO THE SQUARE

THE EXTRAORDINARY SUBTLETY with which colors interact – how one shade can change another and relate to a third – so fascinated Josef Albers that he decided to restrict his paintings to geometrical patterns. By using the square, that most common of forms, he hoped to withdraw the viewer from any involvement in the interest of the actual object. But in blending and relating colors within the square, he hoped that the eye would be infinitely tantalized and delighted by a sense of what color truly was. (He claimed, for example, that he had 80 kinds of yellow alone.) Here, he is playing with a deep pink, with the square that encloses it in an infinitesimally lighter pink, and, outside that, a pale orange – all held within another square of a still-lighter orange. This is the kind of subtle modulation of color that a casual glance all too easily misses. Albers sacrificed so much of the interest and beauty that we expect from a work of art, solely in order to concentrate on this color play. In doing it, he makes us aware of the lovely silence that, with intelligent perception, can flow from one color to another.

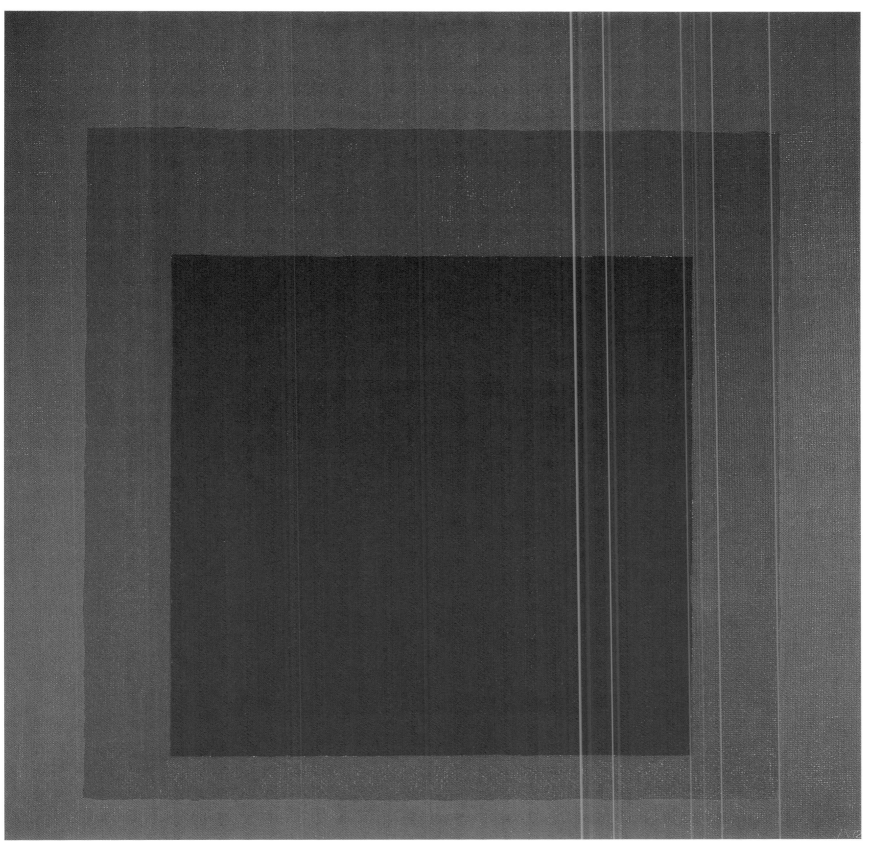

STUDY FOR HOMAGE
TO THE SQUARE,
1972, oil on masonite,
24⅝ x 24⅝ in (62.5 x 62.5 cm),
San Francisco Museum of
Modern Art

AUDUBON, JOHN JAMES 1785–1851 b. Haiti, active US

ARCTIC TERN

EARLY 19TH-CENTURY AMERICA was fortunate to have a great naturalist like John James Audubon, whose eye for the reality of a bird was matched by his capacity to depict it. Audubon was a pupil of the great French artist Jacques-Louis David but he fled to the United States to avoid conscription in Napoleon's army. He made a living in the New World as an artist, hunter, and taxidermist. Unfortunately, the very nature of bird art usually means that the subject must first be dead in order to be painted – as is almost certainly the case here. Audubon's skill is to set the bird in a context that makes us conscious of what this creature was like when living. The arctic tern, swooping like a dive-bomber into the dark seas to spear its fish, is a remarkable image. It is one of 1,065 studies of birds that Audubon painted from life, and which were published in 1827–38 in four volumes entitled *The Birds of America*.

ARCTIC TERN,
1827–38, watercolor,
graphite, and collage,
21 x 14 in (53 x 36 cm),
New York Historical Society

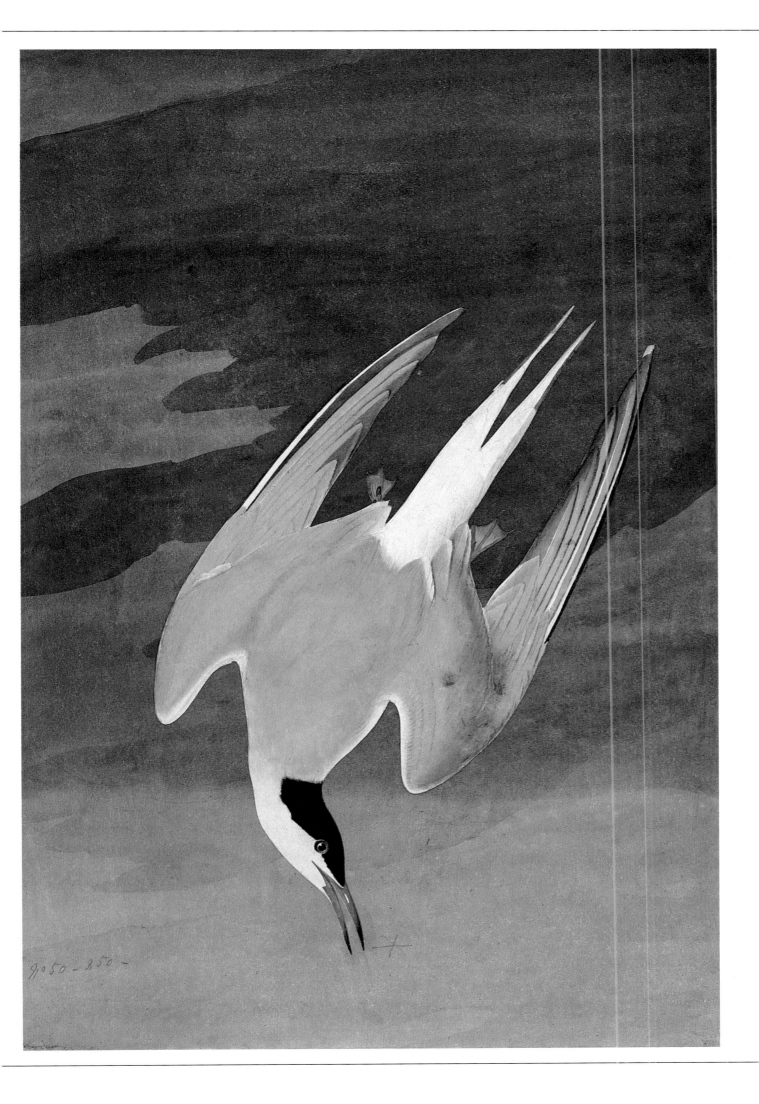

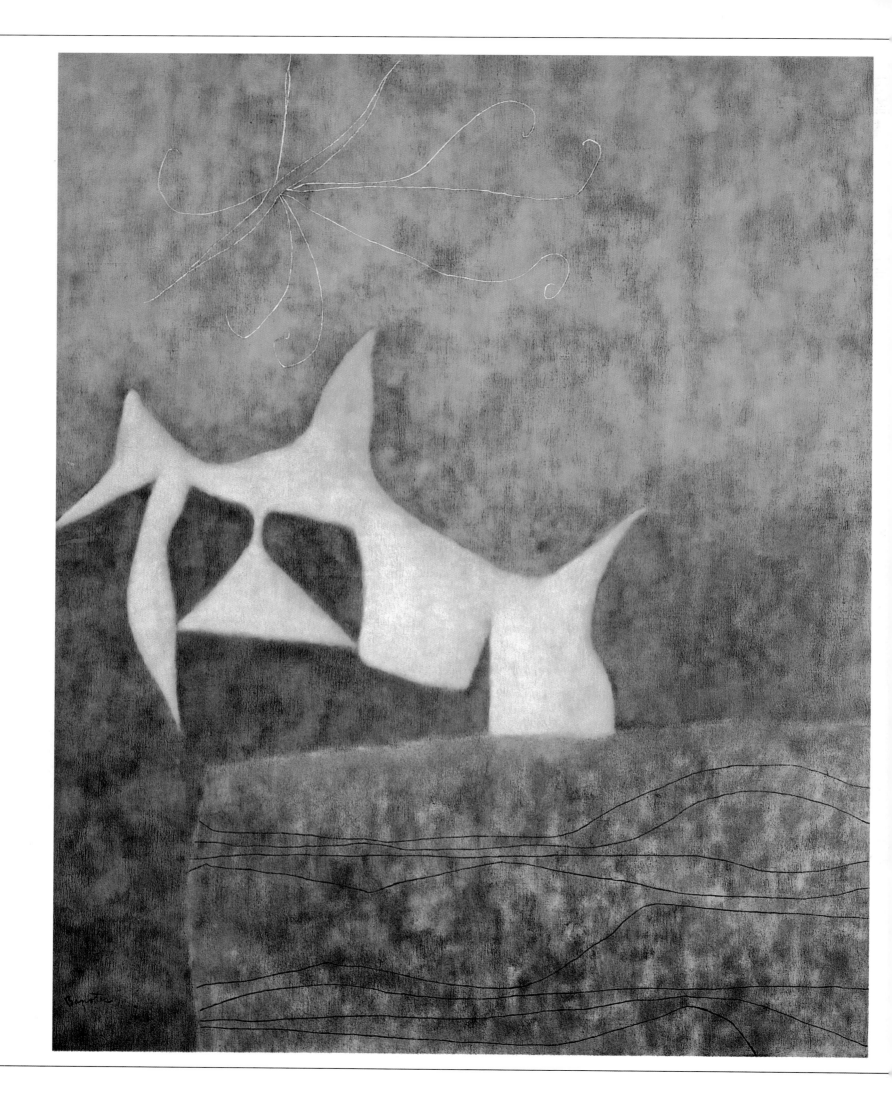

BAZIOTES, WILLIAM 1912–63 b. US
WHITE BIRD

BAZIOTES WAS AN ABSTRACT EXPRESSIONIST and a near contemporary of the movement's most famous practitioner, Jackson Pollock. The first impression one gets when looking at *White Bird* is of the work's extreme beauty – the glorious delicacy of the color, so nuanced and yet so rich. Baziotes was greatly interested in the subconscious, and believed in a primordial art – an art that allowed "a glimpse into the unfathomed abyss of what has not yet become". This is not an easy concept with which to come to terms. The Abstract Expressionists did tend to use grand and cloudy language to explain their intentions, and, ultimately, one can only savor it and see, as it were. How does this interest in the "unfathomed abyss" stand up to what Baziotes has actually created? It seems to me, pretty well. Whatever he thought he was doing, what he has actually produced is a strange and magical shape – some creature, with vague, wing–like extremities, placed on a primordial rock, if one wants to speak the language of Baziotes.

FILAMENTS SWAY *delicately in the air and spread with wavering clarity along the mottled blue of the base. According to his widow, these filaments stood, in Baziotes's mind, for extrasensory perception – the faculty of intuitive understanding, which he felt animals still possessed but humans had lost.*

THE WHITE SHAPE *calls to mind the form of a bird – a rather tempting realism indicated by the title. However, perhaps we limit the picture by attaching precise meanings to these strange and magical shapes. As forms they please us and perhaps it is just that sheer ability to give us pleasure – to suggest a world more magical than any we can actually see for ourselves – that is the achievement of Baziotes.*

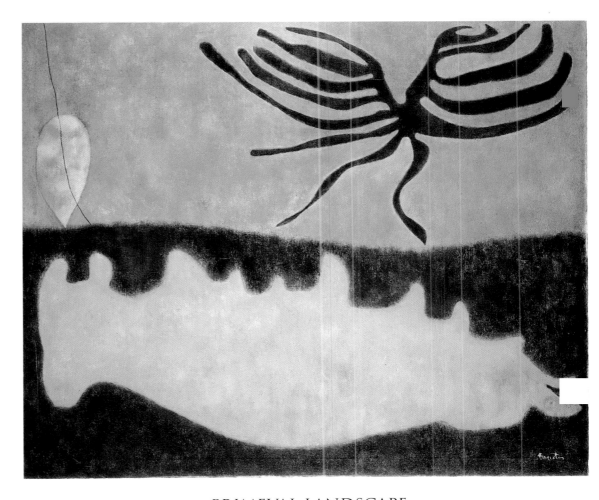

PRIMEVAL LANDSCAPE
1953, oil on canvas, 60 x 72 in (152.5 x 183 cm), Private Collection

Without the title, we might not realize how non–abstract this painting actually is, although it must be stressed that realism is only a relative concept. However, knowing the title of the painting, we can see the prototypal bird, the archaeopteryx, skimming at full stretch over the earth while a luminous mastodon lumbers superbly over the grass. The one puzzle is the radiant shape at the far left. Perhaps this was what the tree might have become had it seized its opportunities? Or is this an extinct tree, as lost to us as the beautiful creatures of air and earth that are represented in this many-colored landscape?

WHITE BIRD,
1957, oil on canvas, 60 x 48 in (152 x 122 cm), Albright Knox Art Gallery, Buffalo, New York, Gift of Seymour Knox, 1957

BIERSTADT, ALBERT
1830–1902 b. Germany, active US

YOSEMITE VALLEY

HAVING TRAINED IN EUROPE, like many American artists of the 19th century, Bierstadt embarked upon a series of expeditions to the far west of America in his late twenties. It was as if he felt a need to know the full scope of his adopted country before he could settle down and paint. What he discovered on these adventures in the West revealed to him the extraordinary majesty of an untouched America. The West was still a wilderness, where native Americans lived without polluting or disrupting the natural majesty of the land. For those in the cities of the East, who until then had had no concept of what the non-industrialized heartland of their country looked like, Bierstadt's work was astonishing and uplifting. Here, the painter glories in the absolute purity and stillness of the lake, the vast blue and golden sky, and the awesome scale of the mountains, which dominate but do not overwhelm the two small human figures.

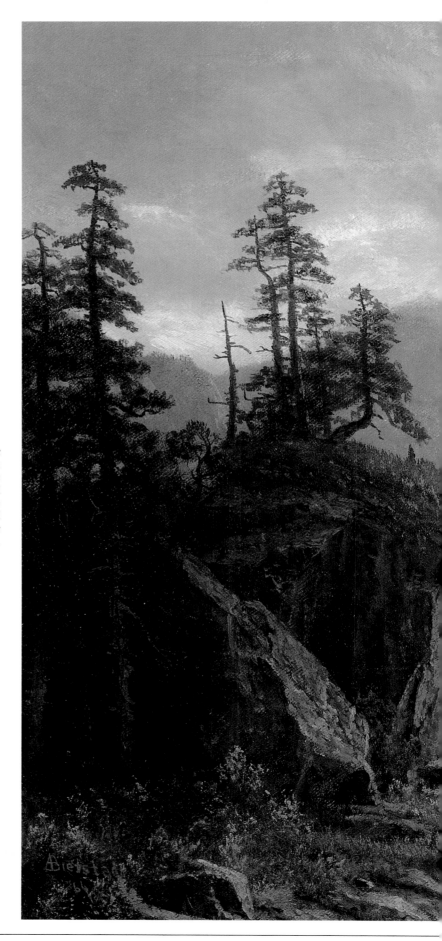

BIERSTADT'S PAINTINGS of the American wilderness also have an implicit spiritual significance. This is a paradisiacal world, a world of great simplicity and purity, into which human beings are privileged to enter, and must do so aware of the responsibilities of their inheritance.

YOSEMITE VALLEY
*c.1863, oil on canvas,
14 x 20 in (36 x 51 cm),
Berry-Hill Galleries, New York*

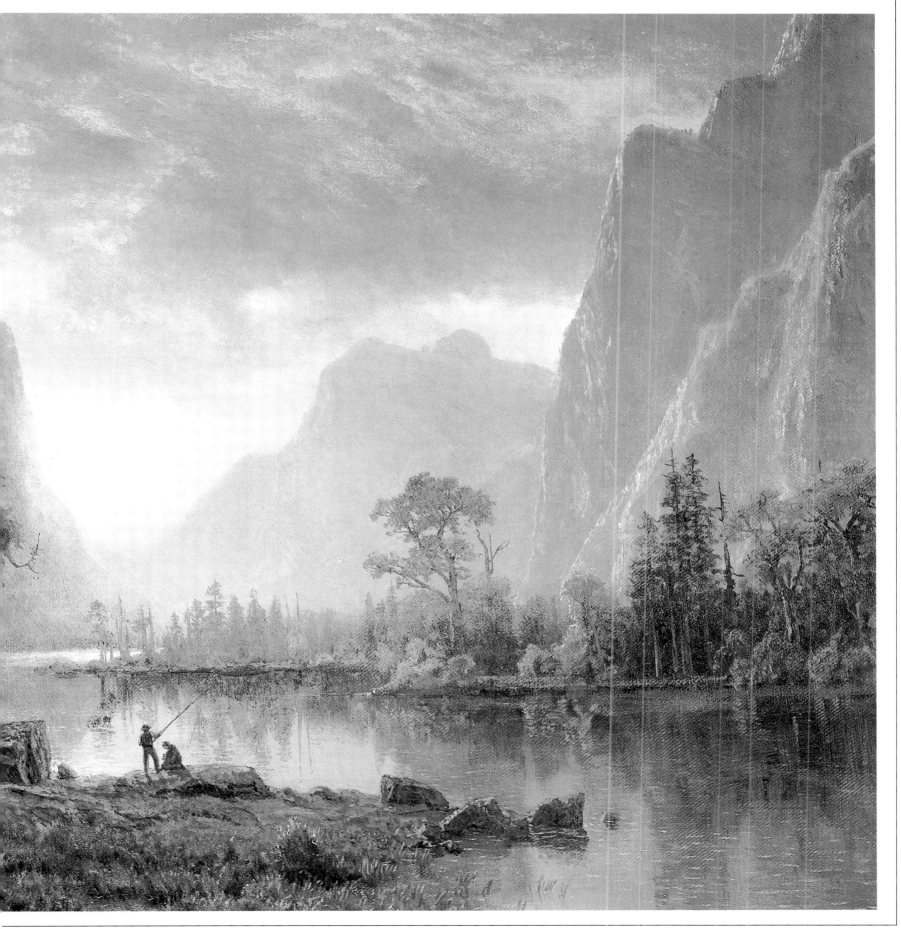

BINGHAM, GEORGE 1811–79 b. US

FUR TRADERS DESCENDING THE MISSOURI

AT ONE LEVEL, this painting describes the economic realities of frontier life in 19th-century America. Two fur traders – or rather the fur trader and his mixed-race son – are making their way down the broad Missouri River to unload their furs at the port. However, this picture suggests so much more: Bingham has caught a glimpse of an idyllic way of life – hard-working, and yet somehow removed from the constraints of time. The boy in his bright blue shirt lounges dreamily on the bales, while the father, equally resplendent in his pink-and-white stripes and his woollen bobble-hat, paddles the canoe with a measured stroke. In the silence and calm of the atmosphere even the little trail of smoke from his pipe seems to hang in the air. It is not just the two men on their boat but the whole untouched world of the Midwest that Bingham makes us conscious of. Behind them are the rough clumps of a mid-river island, with great expanses stretching to the right and left; above, there is the clouded glory of a wide, open sky.

PERHAPS *the most evocative figure is the mysterious animal chained to the canoe, which, in its outline, seems to resemble a cat. The three creatures – two human and one animal – look out at us with a level, unthreatening regard that seems to emphasize the silence and peace of this river setting.*

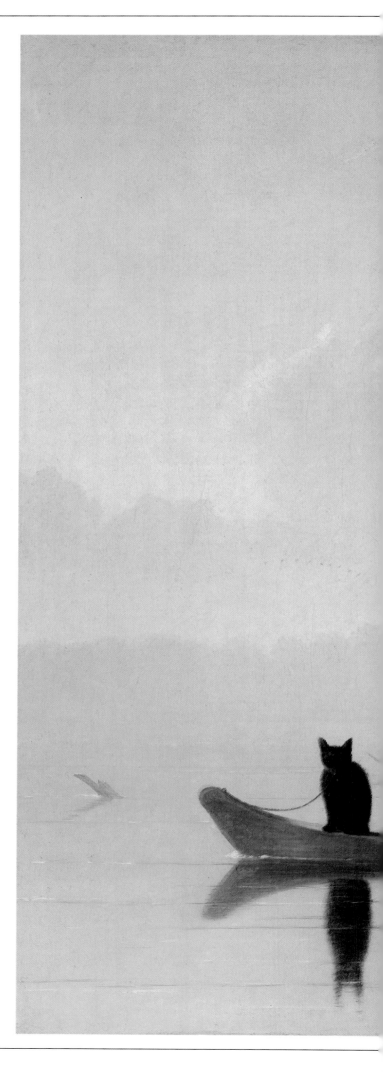

FUR TRADERS DESCENDING THE MISSOURI
c.1845, oil on canvas, 29 x 36½ in (74 x 93 cm), Metropolitan Museum of Art, Morris K. Jesup Fund, 1933

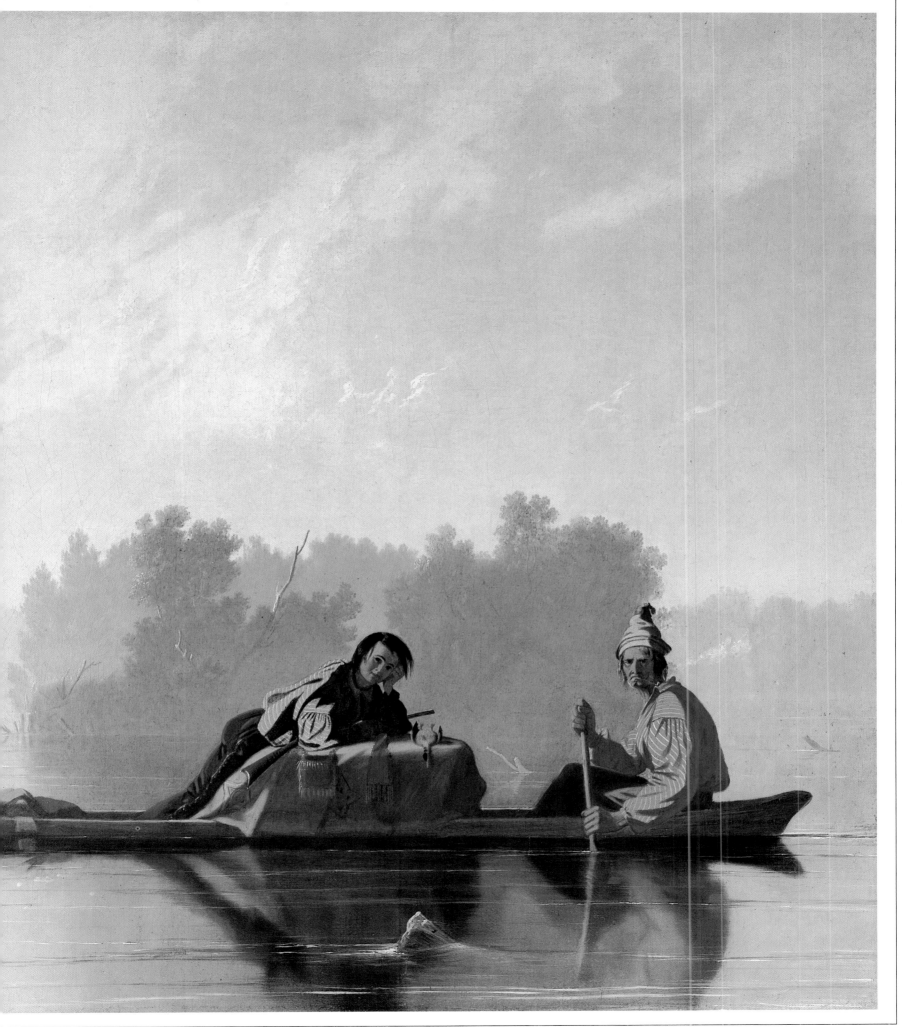

CASSATT, MARY 1844–1926 b. US, active France

GIRL ARRANGING HER HAIR

As a wealthy American spinster, Mary Cassatt was the most unlikely of the Impressionists. Yet, because of the implacability of her eye and the certainty of her sense of form, even Degas was forced to recognize, however unwillingly, that she was an equal. *Girl Arranging her Hair* is an extraordinary painting for the 19th century. It completely disregards any attempt at the picturesque or romantic, and eschews a sense of narrative. For once, we are not asked to ponder on the mental workings of this young woman – on her love life or its absence – but to look at the truthfulness of the painting. The firmness of that flushed face, with its mouth too full of teeth, and the practical plait of her hair are entrancing in their very freedom from romanticism. The simplicity of the wash table behind her, with its curving basin and water jug, and the chair – rather uneasy in its perspective – that frames the girl with a vertical to match the table's, all cause us to see this girl in her voluminous night smock as innocent and spring-like.

Cassatt's paintings have a warm solidity that will not let us encounter them without a genuine confrontation. The surprising thing about this work is that its composition is so appealing in itself we become unaware that the girl herself may not be. It has been said that Cassatt once claimed she could paint an attractive picture of an unattractive person, which is, after all, almost a definition of art.

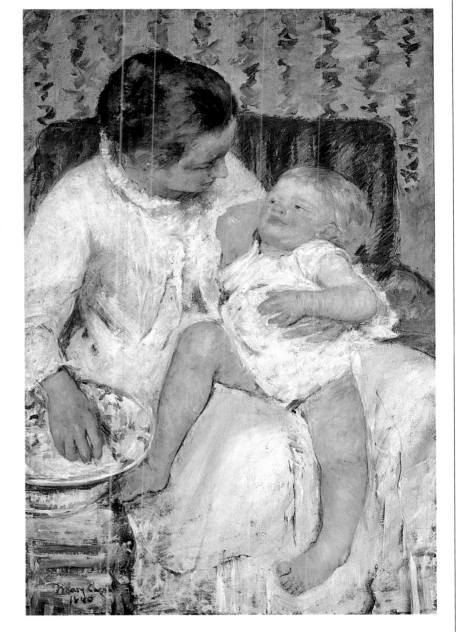

MOTHER ABOUT TO WASH HER SLEEPY CHILD
1880, oil on canvas, 39 x 26 in (100 x 66 cm), Los Angeles County Museum

Although Cassatt herself apparently never wanted marriage and children, many of her paintings deal with these most womanly of relationships. She has a special gift for understanding the intimacy between mother and child, and the happy, relaxed sprawl of this baby on its mother's knee is unusual in art. The baby's leg dangles between the mother's, while the maternal hand rests casually in the water, as if about to pick up the cloth and wipe the child's sleepy face. This is painted by an artist who has looked long and often at babies and mothers and who can show uncomplicated affection with immense skill.

GIRL ARRANGING HER HAIR
1886, oil on canvas, 30 x 25 in (75 x 62 cm), National Gallery of Art, Washington, DC

CHURCH, FREDERICK EDWIN 1826–1900 b. US
COTOPAXI

CHURCH IS SLIGHTLY UNUSUAL FOR A 19th-century
American landscape painter in that his imagination was
first stimulated by the glory, not of his own country, but
by the countries of South America. These were exotic
lands to a citizen of the United States; they were strange
and almost barbarous in their historical associations with
Incas and Aztecs and their geographical associations with
volcanoes. South America had a whole exotic ambience
that contrasted so strikingly with the certainties that
would later be encapsulated in Grant Wood's famous
painting *American Gothic. Cotopaxi*, which depicts an active
volcano in the Andes, made an enormous impact when
it was first shown to the public. This was partly a happy
accident in that its date, 1862, came early in the Civil
War when America was reeling under the impact of its
savagery. For those who saw this magnificent picture, it
was impossible not to see its volatility as a parable for
American society, the industrious order of which had
exploded into an eruption of red-hot violence and pain.

THERE IS A SECURITY *about this
picture in that Church paints it as one
removed to a position of safety above the
scene. He suggests a way of insulating
the heart from the violence, perhaps, by
abstracting it and contemplating the
possibility of moving beyond the dark
and lurid skies on the right and into the
tiny patch of clear blue on the upper left.*

THE WORLD THAT CHURCH *depicts is
the blood-red world of American society.
Although, literally, he shows the Andes, those
barren rocks, those great lonely lakes, and those
heavy skies are all symbolic. There is a terror
in the devastation that corresponds to the
emotional reaction of North and South, and
all is under the threat of those scarlet heavens.*

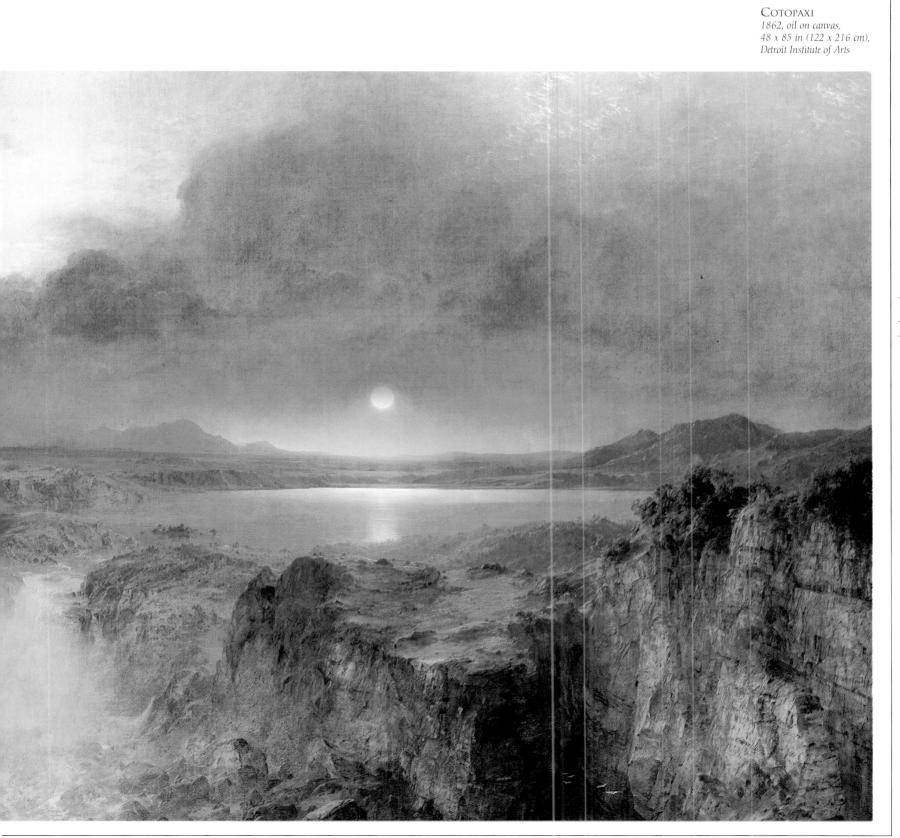

COTOPAXI
1862, oil on canvas,
48 x 85 in (122 x 216 cm),
Detroit Institute of Arts

COLE, THOMAS 1801–48 b. England, active US

SCENE FROM THE
LAST OF THE MOHICANS

IN 1825, YOUNG THOMAS COLE wandered into the American wilderness on an extended sketching trip. Early next year, James Fenimore Cooper published *The Last of the Mohicans*, a great American epic tale of heroism which found a perfect setting in the splendid and lonely mountains. Cole uses this scene from the novel as a pretext for glorifying Lake George and the surrounding countryside. He paints it from above, as if perched on an adjacent mountain looking down on this autumnal wilderness, with its scarlet leaves and the wild rush of the mountain streams. It is a setting as romantic as the novel that Cooper wove around it. Cooper used the potential of the landscape to form his epic novel; Cole uses both book and nature to form his epic landscape.

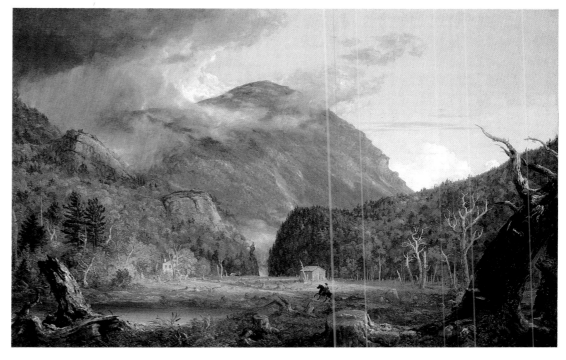

THE NOTCH OF THE WHITE MOUNTAINS

1839, oil on canvas, 40 x 61½ in (102 x 156 cm),
National Gallery of Art, Washington, DC

Here is the stuff of romance: a small white house set bravely in a great wilderness of undiscovered America; a lone horseman; and, overhead, dark rainclouds beginning to lower. It is not the narrative content that interests Cole, however, but the reality of life in the wilderness – the vulnerability of having so little protection against the savagery of nature and the courage that survival requires. Great swathes of forest stretch on either side; here, man is small and nature formidable.

WE DO NOT NEED *an intimate understanding of the story told by Cooper to see that, in Cole's eyes, this is an amphitheatre in which great deeds have been done, great tragedies have been suffered, and great nobility has been quickened. Cole sees these spaces as symbols of the potential of the human spirit.*

SCENE FROM THE
LAST OF THE MOHICANS
*1826, oil on panel, 26 x 43 in
(66 x 109 cm), Terra Museum of
American Art, Chicago*

THE PORCELAIN *fairness of the three girls, the fresh elegance of their clothes, and the exuberance of the spaniels are set splendidly against the backdrop of Windsor Castle; while the pillars above, with their grapes and parrots, hint most subtly at the elaborate lifestyle to which these children are destined.*

FAR FROM BEING POSED, *the three children and their pets play before us in the charming disorder that seems appropriate to their age, and yet which would have been so astonishing to the sensibility of the average courtier. Copley is, perhaps, making a claim that even the bluest blood needs to be allowed to warm itself in the sun.*

THE THREE YOUNGEST DAUGHTERS OF GEORGE III, *1785, oil on canvas, 105 x 73 in (266 x 186 cm), Collection of Her Majesty The Queen*

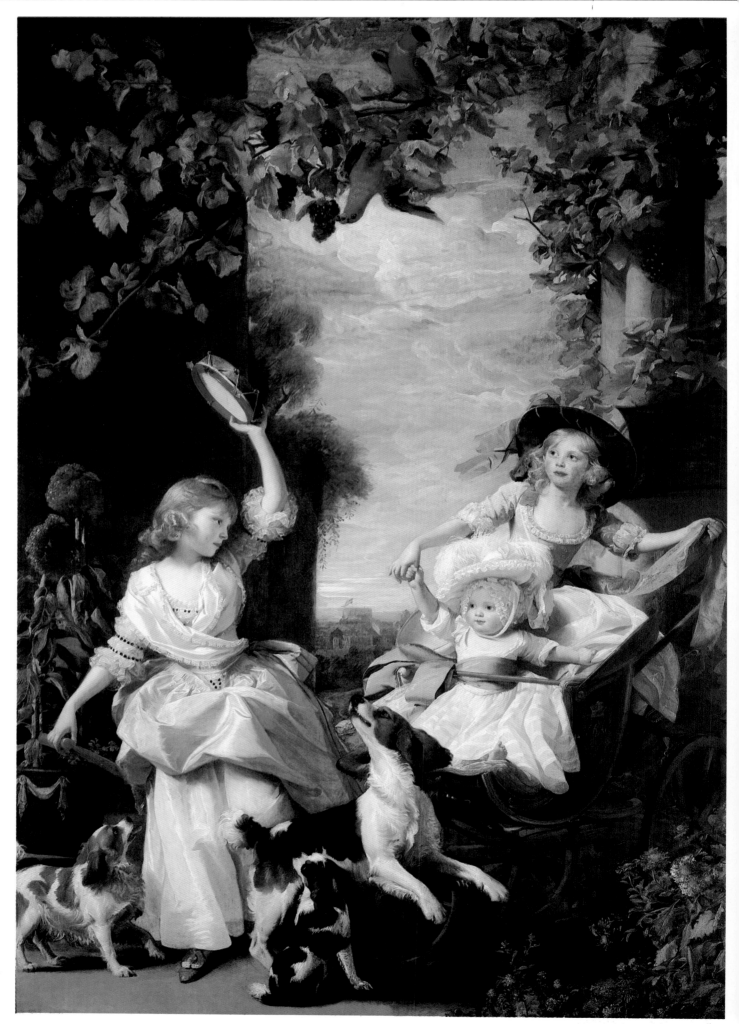

COPLEY, JOHN SINGLETON 1738–1815 b. US

THE THREE YOUNGEST DAUGHTERS OF GEORGE III

NOT ALL AMERICANS stayed to fight in the War of Independence. Copley left the country for Britain, not from a lack of patriotic feeling, but because he felt he needed the scope of a wider and more settled society. His success in 18th-century London can be gauged by the prestigious commissions that most flatteringly came his way. This is one of his most enchanting works. What makes the picture so significant is not that these three are princesses, but that they are three charming and distinctive young women, each of whom Copley has understood as an individual. The relationship between the three little sisters is delightful, too, especially the nine-year-old Princess Mary, who shakes a tambourine to amuse baby Amelia.

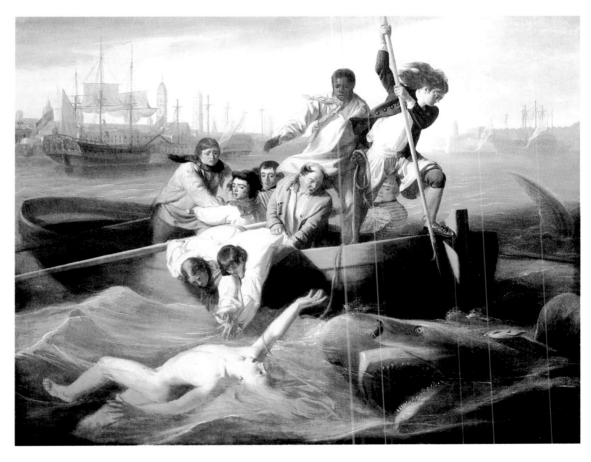

WATSON AND THE SHARK
1778, oil on canvas, 71¼ x 90½ in (182 x 230 cm), National Gallery of Art, Washington, DC

In his youth, General Watson suffered a horrific attack by sharks when swimming in Havana harbor. Three times he was mutilated while the heroic crew fought to rescue him. Copley thrills at the drama, the heroism, and the incipient tragedy, and – born storyteller that he is – leaves us uncertain as to the outcome. In itself, the shark is the least convincing element of this lurid story, but we are wholly convinced by the emotion and fear of the human beings involved. It is said that this picture made Copley famous, and it is not hard to believe that he would have been suddenly lifted into fame by this painting's dramatic tension.

DAVIS, STUART 1894–1964 b. US

ODOL

STUART DAVIS WAS ESSENTIALLY AN ABSTRACT ARTIST, but not at all in the sense of the Abstract Expressionists. He scorned their work, describing it (I am sorry to tell you) as a belch from the unconscious. Davis had no time for the unconscious and had no truck with any grandiloquent plans for a mystical or spiritual art. His aim was not to express the higher things of life but rather to do as the poet Walt Whitman had done before him – to make art out of the world in which he lived. In this sense, Davis was a Pop artist

years before the movement began. *Odol* demonstrates his methods perfectly. In this painting, he takes a humble toilet accessory, a mouth freshener, and uses it to make an abstract, flat, decorative pattern. Davis's play on shapes depends upon our recognition of the real world, a familiarity with its objects, and an understanding of their functionality. In his attention to the ostensibly insignificant, Davis does not try to elevate objects to a higher status, but merely to represent something of contemporary American life.

FOR DAVIS, abstract art was not an ego trip or a vague device for creating "beauty", it was a way of responding to the clean lines of the modern world. He felt that unless artists recognized the aesthetic potential before them, they were living in a pseudo-world and refusing to allow the genuine environment its rightful place in art history.

JUST AS WARHOL would be later attracted to the Coca Cola bottle, so Davis is drawn, here, to the Odol bottle. He likes the shape of it and the lettering upon its surface and so he has made a multicolored framework in which to highlight this modern device, with its cunning, squirtable opening and the simple clarity of its message.

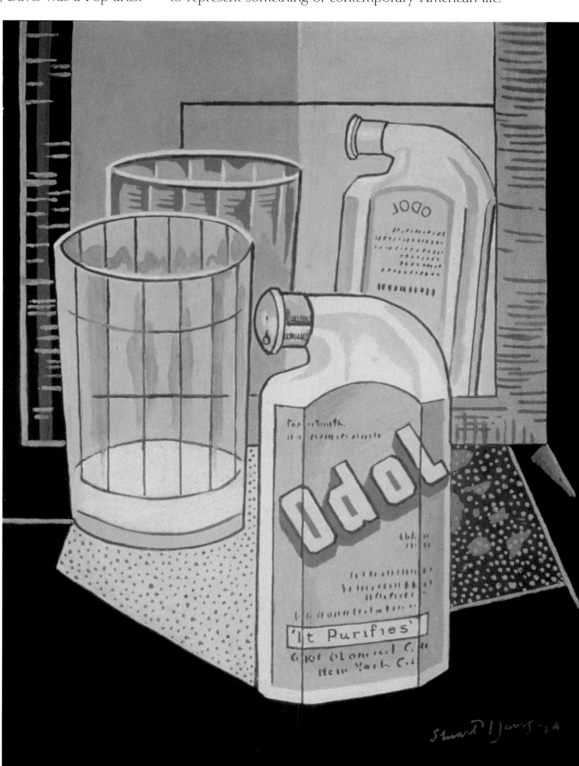

ODOL,
*1924, oil on canvas,
24 x 18 in (61 x 46 cm),
Cincinnati Art Museum*

COMPOSITION CONCRETE
1957, oil on canvas, 203 x 96 in (515 x 244 cm),
Museum of Art, Carnegie Institute, Pittsburgh

Thirty years later, Davis has a more complex vision.
Here he is thinking not so much of clarity as of
complexity, of jazz rhythms. *Composition Concrete* was
commissioned for the lobby of the Heinz company
building in Pittsburgh and the date, 1957, which
has been incorporated into the painting, is a witty
reference to the company's 57 varieties. Davis
deliberately uses red, white, and blue for patriotic
reasons and here he plays with colors and shapes
as jazz musicians play with sounds. He also delights
in the flatness of geometry with which he makes
his colors cohere into a consistent pattern.

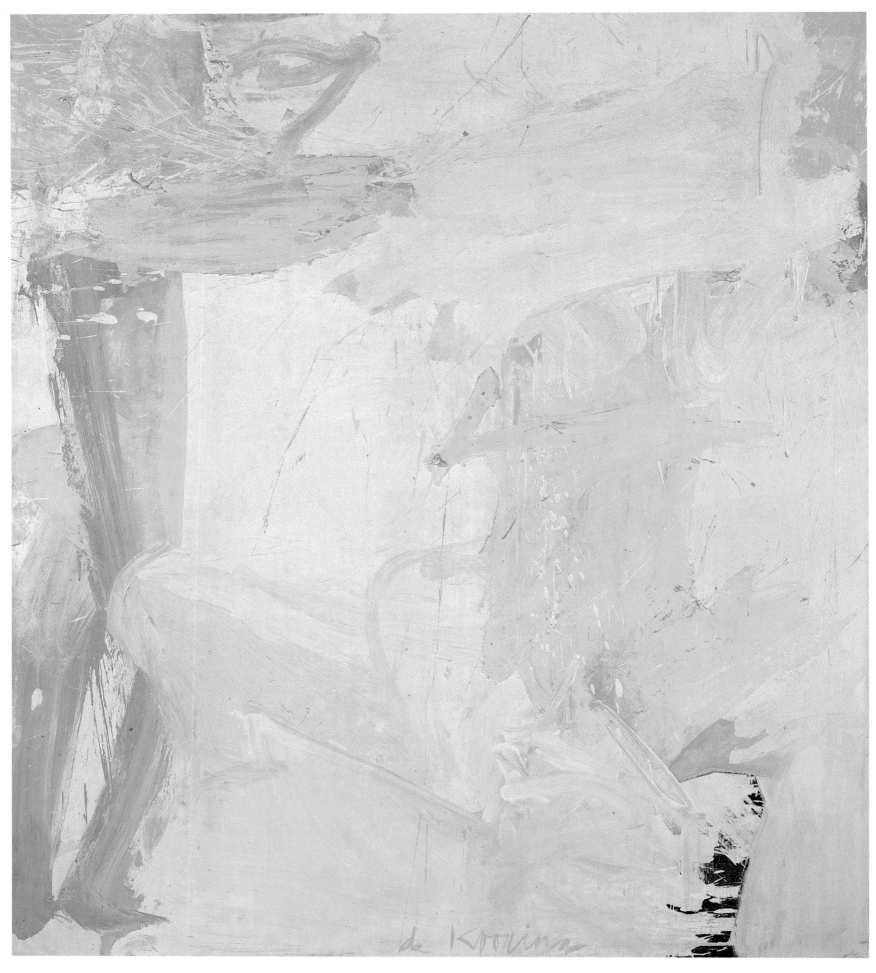

ROSY-FINGERED DAWN AT LOUSE POINT
1963, oil on canvas, 80 x 70 in (204 x 179 cm),
Stedelijk Museum, Amsterdam

DE KOONING, WILLEM 1904–97 b. Netherlands, active US
ROSY-FINGERED DAWN AT LOUSE POINT

ROSY-FINGERED DAWN AT LOUSE POINT is de Kooning's reaction to a real, although rather unromantically named, place. He was living in Long Island, close to Louse Point, when he painted this work and in the early morning he could see light flooding tenderly over the vast, flat fields. It reminded him (well-educated Dutch schoolboy as he had been) of Homer's description of dawn with its "rosy fingers". His painting makes no attempt to describe, literally, those fields and the early-morning brightness, but it gives us a sense of a sweet and gentle light before the midday sun becomes harsh. We can, if we like, read in the upper-left the faint green-and-white surgings of the sea on the headland, and perhaps the lines so strictly demarcating the soft pink and the radiant whites suggest to us a field and fences, with possibly a house or a small dam of water; these, however, are the merest suggestions of physical reality. His brush, one could imagine, moved almost automatically as he gazed, seeking to recreate for us the bliss of being young, with the whole day to paint and a whole world to delight in.

IF WE TIE DOWN de Kooning's imagery too specifically, we spoil that glorious awareness of freedom. Prosaic talk about this rectangle or that being a field or a stretch of woodland turns what is actually a glorious evocation of place into what would then seem to be a rather unsuccessful attempt at topographical description.

ONE WOULD NOT NATURALLY link de Kooning to that other great Dutch painter Vermeer, but both have as their primary concern the glory of light. De Kooning is painting that extraordinarily tender and gentle first light, which floods freely over his American home, unveiling its beauty and mystery.

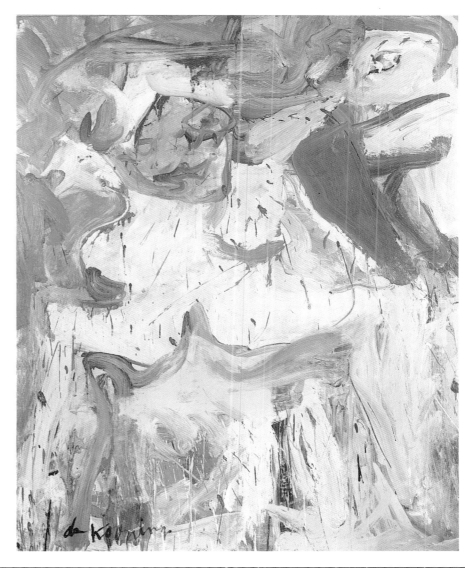

THE VISIT
1966–67, oil on canvas, 60 x 48 in (153 x 122 cm), Tate Gallery, London

De Kooning has been accused of fearing and even hating women; certainly this is a violent picture, and so horrifying that one hesitates to call it a masterpiece. It is masterly, however, in the savagery of its execution and the power with which the artist destroys our expectations. Because there is so much pink flesh and because de Kooning had already painted large pink women, *The Visit* has been attached to his *Women* series. But this is too easy a classification, for the image is more like a slaughtered ox – something hacked at and partially devoured. It carries such power and conviction that one cannot look at it unmoved.

DEMUTH CHARLES 1883-1935 b. US
I SAW THE FIGURE 5 IN GOLD

I SAW THE FIGURE 5 IN GOLD was painted in honor of Charles Demuth's old friend of nearly 25 years, the poet William Carlos Williams. It is perhaps Demuth's greatest work. The composition was inspired by a phrase from Williams's poem *The Great Figure*: "Among the rain and lights I saw the figure 5, in gold, on a fire truck, moving, tense, unheeded, to gong, clangs, siren howls, and wheels rumbling, through the dark city." Demuth's work is an interpretation of Williams's evocative imagery. Demuth chooses a vibrant red and yellow palette to raise the temperature and to create an emotionally charged atmosphere. What makes this work so magnificent is the orchestration of color and shape into movement.

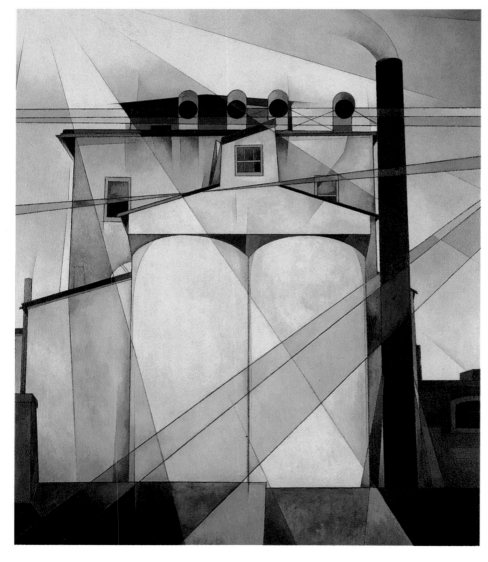

WE SEE THE *fire truck as if moving at speed along the street. The great "5" emblazoned in gold fills the space, and then the "5"s become smaller and smaller as the truck hurtles into the distance with the sirens going. Williams's poem described this event in the rain, and so here we have the full drama of the slanting diagonals of rain whipping across the vehicle, reminding us of the treacherously wet streets, and filling us with exhilaration.*

THIS IS NOT JUST *a description in paint but truly a homage to the great American poet William Carlos Williams. There are several references to him in the painting. At the top of the frame is the name Bill, Demuth's nickname for his friend, and then to the right, picked out in lights, stands the nightclub Carlo. Finally, in discreet but precise lettering at the bottom of the frame are the initials "WCW", while in the center right, Demuth declares that this is "art co" – a joint artistic venture with the poet.*

MY EGYPT
1927, oil on board, 35¼ x 30 in (91 x 76 cm), Whitney Museum of American Art, New York

My Egypt is one of Demuth's most personal and contemplative paintings. He chooses a utilitarian piece of farm machinery, the grain elevator, as his subject, but treats this American construction with monolithic grandeur, drawing a comparison with the pyramids of Egypt. The monumental simplicity of the elevator is clearly as satisfying to the artist as the geometry of an Egyptian temple. It has even been suggested that Demuth is thinking ahead to his death. His health was declining, and perhaps he saw this work as his memorial, just as the pyramids were to the Pharoahs.

I SAW THE
FIGURE 5 IN GOLD
*1928, oil on composition board,
36 x 29¼ in (91 x 76 cm),
Metropolitan Museum of Art, New York*

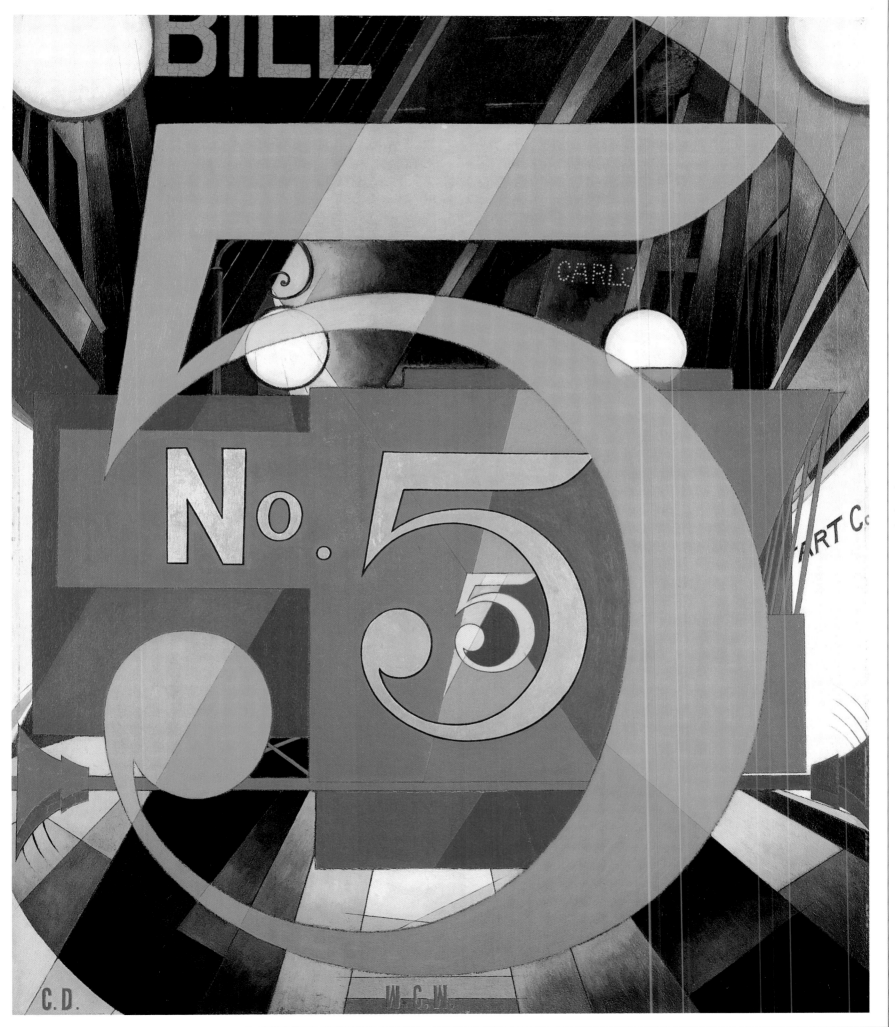

AS ONE LOOKS at the painting one is struck by the diagonals, with their apparent inconsequence, and behind them one can see subtle bands of layered and various blues mixed with faint pinks. It is as if the artist is playing with the whole concept of blueness. This, in turn, suggests water, in which we see various intensities of color and degrees of clarity as we look into and through it.

THE MORE one contemplates Ocean Park No. 136, the more pure and subtle it appears to be. The red line at the bottom deepens and broadens as it moves to the right and above it a band of the palest orange is only free to reveal itself a third of the way across the picture. Such relationships of color and form mount up, and the picture begins to integrate itself into a complex and magnificent whole.

OCEAN PARK NO. 136
1985, oil on canvas, 60 x 60 in (152 x 152 cm), Private collection

DIEBENKORN, RICHARD 1922–94 b. US
OCEAN PARK No. 136

DIEBENKORN'S BEST-KNOWN WORKS form a series of paintings, each entitled *Ocean Park*. Because so many of the paintings contain large expanses that are blue one may be tempted to think that he is painting the ocean but the name, in fact, comes from a Californian suburb. However, there is a certain truth here, in that the suburb is within sight of the great Pacific depths and the precise squaring of the canvas, with its boxed edges and its geometric alignments, is a happy amalgam of the suburb – with the certainties of its enclosures, plots, and bisecting roads – and the pure freedom of the ocean, where color ebbs and flows by its own laws. Diebenkorn was always torn between realism and abstraction and one senses that in these glorious (and indeed, abstract) paintings he is expressing something of the light, color, and freedom that is said to be typically Californian.

URBANA
*1953, oil on canvas, 66 x 49 in
(168 x 125 cm), Private Collection*

Urbana suggests that the artist is looking down upon an urban area, yet nothing is made explicit. The eye is kept in motion as it moves across the planes laid out before us, much as the artist would be if he were sailing in a great balloon over an urban sprawl, catching its emotional color and occasional configurations, but unwilling to commit himself to the drab particularity of the specific.

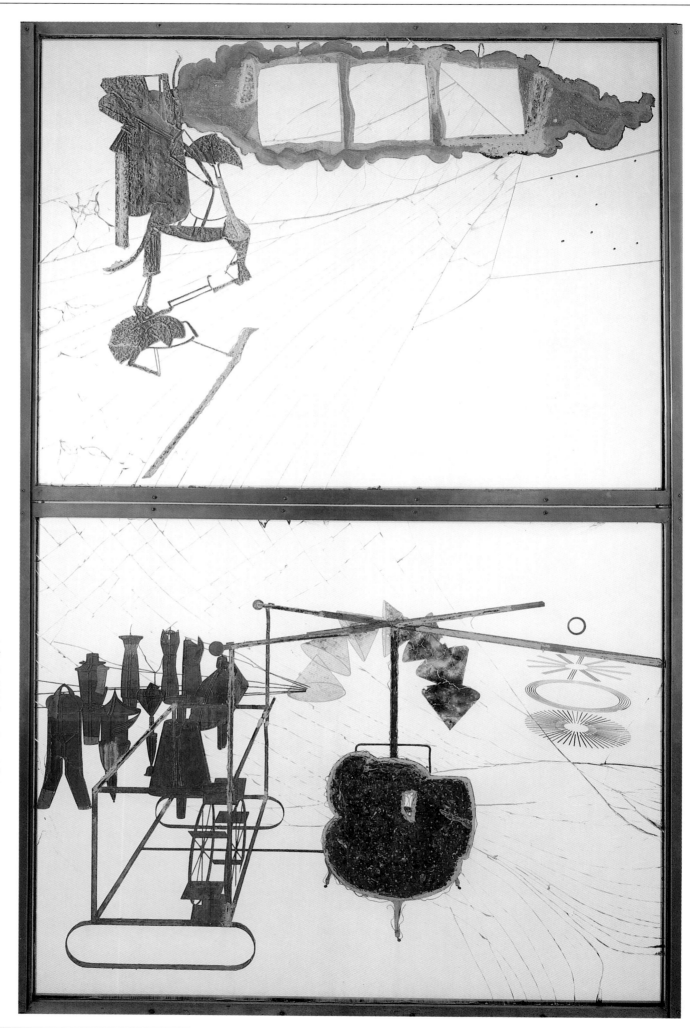

DUCHAMP IS CLEARLY *playing with the idea of "otherness" in respect of male and female genders. He is playing with the physical mechanisms – the machine mechanisms of the body – on the occasion when these two "others" meet most intimately on the night of marriage. With a lofty disregard for romance, he presents this union as something material, clinical, and almost as mindless and contemptible as the grinding of machinery.*

THE BRIDE STRIPPED BARE
BY HER BACHELORS, EVEN
*1915–23, oil and lead wire on glass,
109 x 69 in (277 x 175 cm),
Philadelphia Museum of Art*

DUCHAMP, MARCEL
1887–1968 b. France, active France and US

THE BRIDE STRIPPED BARE BY HER BACHELORS, EVEN

DUCHAMP SEEMS TO BE THAT STRANGE ANOMALY – an artist who does not believe in art. We can take this back still further: he did not believe in reason or even in life, and yet from these disbeliefs he created works that still fascinate us today. In fact, as the great exponent of conceptual art – the art of the idea – Duchamp has had more influence over our century than even Picasso or Matisse. *The Bride Stripped Bare by her Bachelors, Even* is almost an anti-painting. There are two glass panels: the top is the domain of the bride and the bottom the domain of nine manly-molded forms of bachelors. Between the bride and the bachelors are the eternal, immovable bars that divide them.

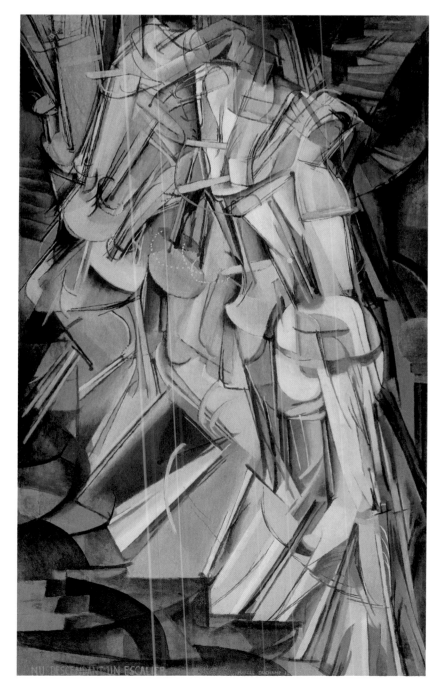

NUDE DESCENDING A STAIRCASE, No. 2

1912, oil on canvas, 38 x 24 in (96 x 60 cm), Philadelphia Museum of Art

When contemporary art first came to America in force at the famous Armory Show of 1913, this was the work that so shocked innocent viewers who had always regarded art as something comprehensible. Without the title one could not tell what Duchamp was representing; with it, one can grasp that there is a figure moving down a flight of stairs. Typically, Duchamp is tantalizing the viewer by calling the figure a nude and then presenting what looks like copper machinery clanking down the steps clumsily and heavily. The brilliance of the picture was that it forced the viewer to rethink attitudes toward an image, perhaps even to rethink attitudes toward the body and movement.

EAKINS, THOMAS 1844–1916 b. US
THE BIGLIN BROTHERS RACING

THIS IS PROBABLY ONE OF THE GREAT ICONS of American painting. In itself, the scene seems almost like a snapshot of reality. We notice that the racing skiff is not contained by the canvas and that another skiff is bearing fast up at the bottom of the picture. Yet what Eakins has done is to convey, in a single painting, something of the courage, spirit of competition, and athletic force of late 19th-century America and show it in a setting of extraordinary beauty. The waters that for centuries were either disregarded or used as a primitive means of transport between isolated areas have been cultivated into an area where men can extend their athletic abilities for the sheer pleasure of it – the sheer pleasure of action and competition.

THE BIGLIN BROTHERS RACING,
1873/74, oil on canvas, 24 x 36 in (61 x 91 cm),
National Gallery of Art, Washington, DC

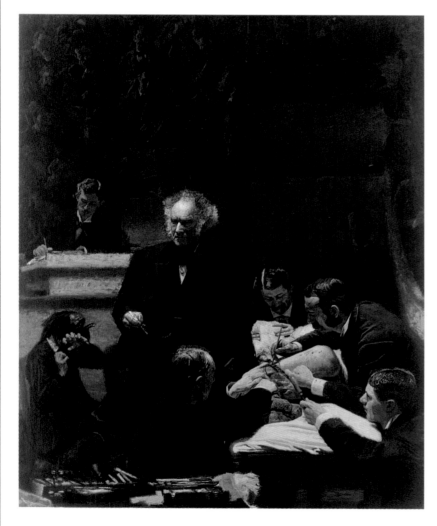

THE GROSS CLINIC
1875, oil on canvas, 96 x 78 in (244 x 198 cm),
Jefferson Medical College, Thomas Jefferson University, Philadelphia

Eakins was a great portrait painter with an innate sense of drama, and here we see these qualities at fullest stretch. The famous Professor Gross is lecturing as he and his assistants perform a delicate operation on the human leg. The patient's body is curled up on the operating table, while the anaesthetist holds a cloth to his face. One would think that this naked and suffering body would be the center of the picture but in fact our attention is focused on the gleaming forehead of the professor.

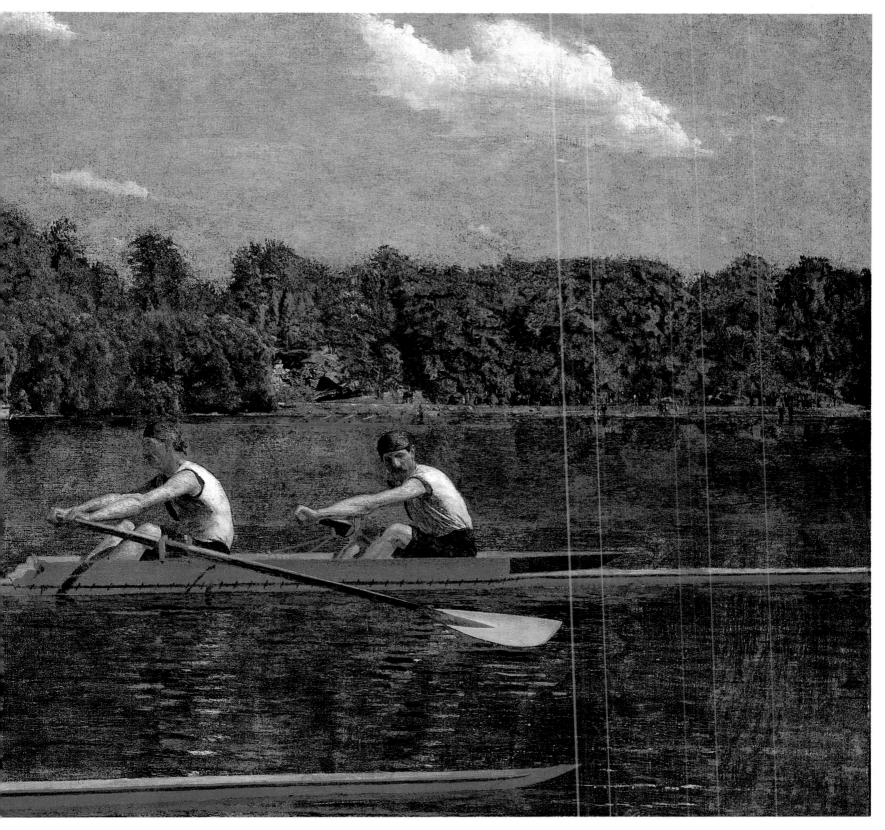

ON THE DAY that this contest took place, a great storm caused the race to be delayed until the early evening. Eakins, however, has used poetic licence to set the scene in the light of mid-afternoon, with a brilliant blue sky above.

WE CAN FEEL the tension of the race because Eakins has almost pushed us up against it. We are there, with the Biglin boat sliding off the canvas and a competing sliver of a boat creeping up behind.

MARKET CHURCH
AT EVENING,
*1930, oil on canvas,
38 x 33 in (101 x 85 cm),
Alte Pinakothek, Munich*

MARKET CHURCH AT EVENING *is painted from a low
perspective so that, as the church soars up with its pointed,
triangular towers, our eyes follow the diagonals of color
skyward. There is an extraordinary sense of height and
grandeur. Feininger manages to simultaneously convey the
strength of stone and the lightness of all things material.*

FEININGER'S VISION *extends beyond the architectural to the natural. The
sky, too, is fractured and slanting, deepening the impression of a world
that we see only in flashes and glimpses – a world that will never
stand still for our contemplation. While in Paris, Feininger met the
Orphic Cubist Robert Delaunay, whose experimentation with fractured
color had considerable influence on Feininger's work.*

FEININGER, LYONEL 1871–1956 b. US, active Germany

MARKET CHURCH AT EVENING

LYONEL FEININGER IS UNUSUAL in that he was an American artist who spent most of his working life in Germany, only returning home when the Nazis came into power. He lived in Weimar, teaching in the famous Bauhaus school where Klee and Kandinsky were fellow teachers. Feininger developed a vision of the world that is specific to himself, although dependent on Cubism for the fractured nature of its expression. He depicted the world in great slanting triangles. It is a world portrayed obliquely, formed, as it were, out of angled spotlights that meet and thicken and coalesce. Here he is painting a market church in the evening light. It is a great Gothic sculpture with black, indeterminate marks at its base – mere notations that manage to convince us of worshippers passing into the church, and which emphasize the massive scale of the building itself.

SAILING BOATS

1929, oil on canvas, 17 x 28 in (43 x 72 cm), Detroit Institute of Arts

In *Sailing Boats*, Feininger puts his vision of diagonals, triangles, and fractured light to superb use. Sailing boats moving rapidly over a broken sea lend themselves well to Feininger's triangular scheme, and the swooping movement here is exhilarating. We are buffeted by the overlapping diagonals of the sails and air, with the slanted waves underneath, and with the almost audible whistle of movement as the air hurls past; this is one of the most invigorating experiences in 20th-century art.

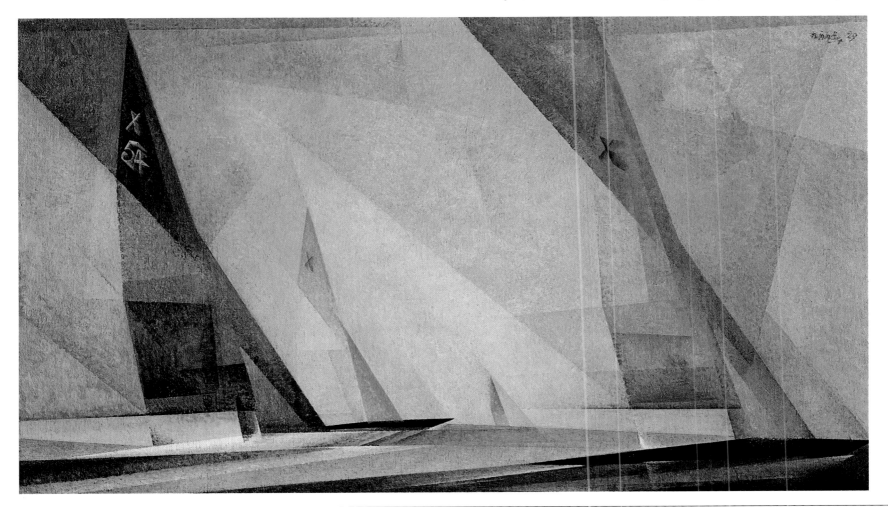

DURING WORLD WAR II, Sam Francis was a pilot serving in the American Army Air Corps. He had an accident towards the end of the war which developed into spinal tuberculosis, and he was forced to spend several years on his back in army hospitals. It was this prolonged period of illness and convalescence that gave him the opportunity to investigate painting. At first his work was conventional, but then as he grew in confidence he began to express himself in original works that were predominantly blood-red in color and suggestive of bodily tissue. This concern with his own blood, his fear about his future health, slowly modified into works such as *Red and Pink*, which he painted later once released from the hospital and healthy. On this very large canvas Francis has slowly created for himself a sense of space and freedom.

THIS IS A VERY EARLY PAINTING *and it has been suggested that its hazy fluidity may owe something to the artist's move to Paris in 1950. Californian light has a brilliance very different to the soft, almost watercolorlike luminescence of* Red and Pink – *so expansive, so gentle, and so subtle.*

WE CAN STILL SEE HERE *a suggestion of blood cells but Francis has moved from an anxious personal involvement to an understanding that behind the pink and the red is a translucency of white. This is not a painting by a man controlled by his body, but a man controlled solely by his own imagination.*

THERE IS ENORMOUS BALANCE *here, enormous patterning. Francis floats the picture, softening here, thickening there, understanding that what he is doing is to create an image of shimmering light over which flow soft areas of both almost transparent pink and more intense red. Francis uses color purely to create and the creation is an act of joyful freedom.*

AROUND THE BLUES
1956/7, oil and magma on canvas, 43 x 76 in (108 x 192 cm), Tate Gallery, London

The title of this very large picture suggests an analogy to jazz. Just as the jazz musician creates around a theme – sweeping up and down, a crescendo here, a diminuendo there, following solely the push of his interior music – so is Francis playing with color. The white is actually that of the canvas itself, the ground, and on it he has lavished oil with complete yet controlled freedom.

RED AND PINK,
1951, oil on canvas, 82 x 66 in (208 x 167 cm), San Francisco Museum of Modern Art

FRANKENTHALER, HELEN 1928– b. US
MOUNTAINS AND SEA

THROUGHOUT ART HISTORY, artists have painted on a support: wood or wall or canvas. Helen Frankenthaler changed the whole story of painting when, in 1952, she created *Mountains and Sea* not by painting on her canvas but by painting in it – by staining it. She laid an enormous piece of canvas on the floor and onto its porous surface poured thin paint from coffee cans. It was by no means an exercise in sheer abstraction. She had visited the mountains and sea and came back knowing that, as she put it, "the landscapes were in my arms". In her mind, it was clear that she was creating not a representation of landscape (she says the title is merely a "handle with which to grasp the painting"), but an experience of landscape, a sense of being there, amidst the vastness of the sunlit mountains and the vastness of the great expanse of sea.

MOUNTAINS AND SEA, 1952,
oil on canvas, 87 x 117 in (220 x 298 cm),
National Gallery of Art, Washington, DC

FRANKENTHALER CREATED *an incredibly daring way to paint. There was clearly control in her method but she took risks and used no brush to guide her. The picture struck all who saw it and immediately gave rise to a new kind of painting; she, however, has not been bettered.*

BRIDE'S DOOR
1967, acrylic on canvas, 82½ x 60¼ in (210 x 154 cm),
Collection Becy and Pete Smith, Sun Valley, Idaho

This is a majestic painting of great confidence.
It is not, we feel, a work planned and
composed but one that took on its meaning
for the artist as it took shape on the canvas.
Frankenthaler seems to paint from a deep
poetic instinct. There is a great opening here –
a door if we like – giving way to the complete
unknown that is marriage. Frankenthaler does
not paint bridal experience and yet the title is
not inappropriate for this image.

" *Frankenthaler demands a place*
in art history as a pioneer of
the staining technique **"**

GORKY, ARSHILE 1904–48 b. Armenia, active US

HUGGING/GOOD HOPE ROAD II

ALTHOUGH GORKY BECAME AN AMERICAN CITIZEN whilst still in his teens, he was by birth and temperament an Armenian. No label seems to fit him, and there is no category on which we can rely to explain the strange magic of his best works. For much of his early life, Gorky copied other artists – above all Picasso – obviously at some level fearful of his ability to "go it alone," as it were. Even in this wonderful picture, where he clearly is going it alone, we might well wonder whether there is a debt to Kandinsky. Gorky, an inveterate liar, claimed to have studied with Kandinsky, but there may be a subliminal truth beyond the factual. He had certainly studied Kandinsky, and understood that strange use of color as emotion that was Kandinsky's special gift.

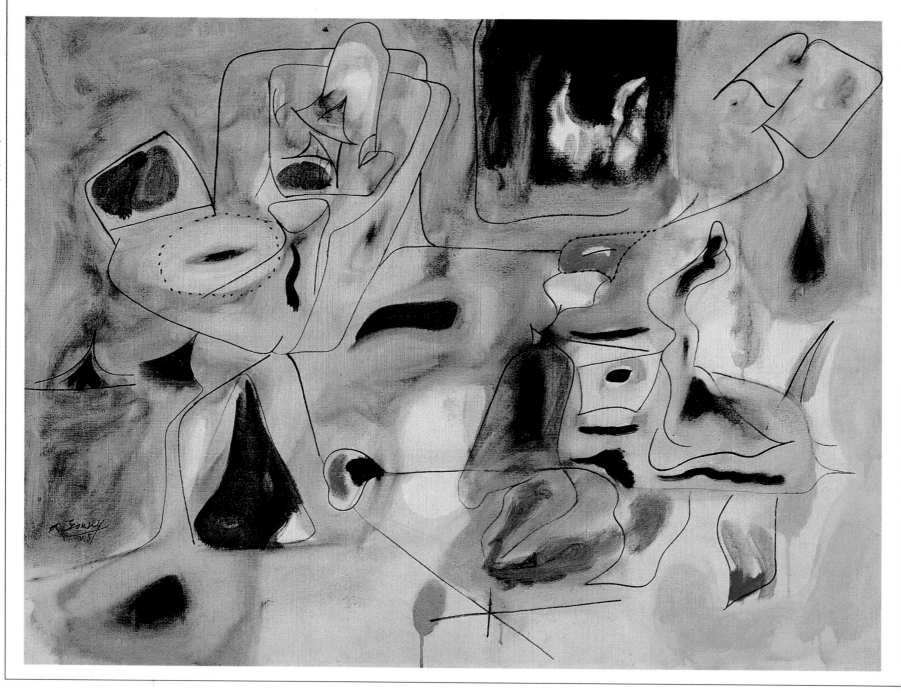

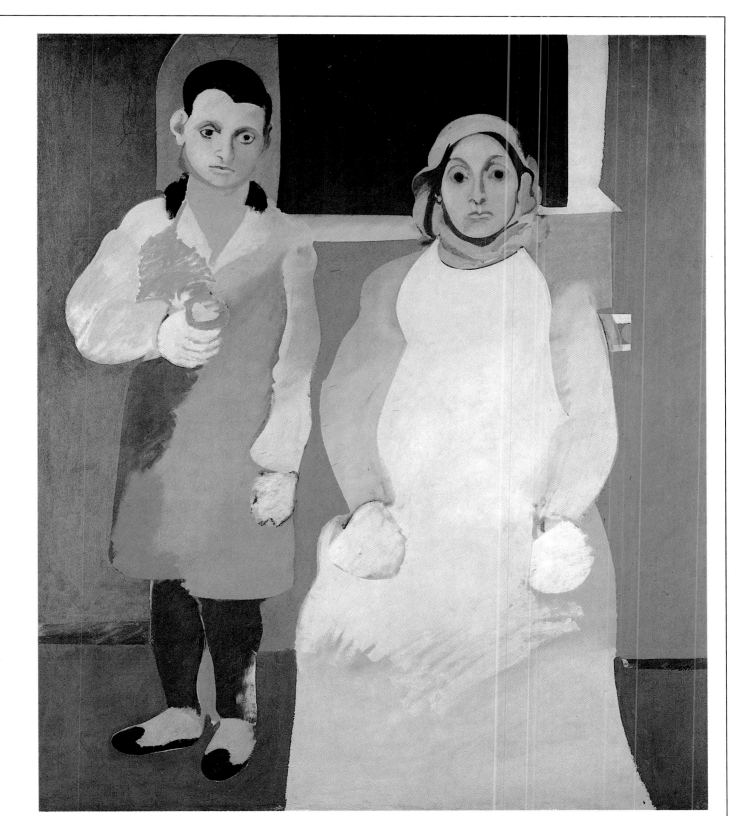

THE TITLE DOES *not
shed much light on
what is happening here.
Imaginative commentators
have seen roads, windows,
and mountains – and
these readings may well be
true. Equally, we can write
them off as fantasy, which
in the end discredits the
power of the work.*

WHAT GORKY *has
given us is a great
rectangle that encloses a
small dark square; but
it also encloses strange
magical shapes, colors,
squiggles, and circles.
It takes us into a world
where we float free, where
we do indeed feel embraced,
where our hope becomes
almost tangible.*

HUGGING/GOOD HOPE
ROAD II (PASTORAL),
*1945, oil on canvas, 26 x 33 in
(65 x 83 cm), Thyssen
Bornemisza Museum, Madrid*

THE ARTIST AND HIS MOTHER
1926–36, oil on canvas, 60 x 50 in (152 x 127 cm), Whitney Museum of American Art, New York

So many of Gorky's stories turn out to be fictitious, and yet, whatever the truth behind his
mother and her death from starvation, she mattered enormously to him. He had a photograph of
himself as an adolescent in a foreign country with his mother. The image of the "strong woman",
with her big Armenian eyes, and the pathetic child trying to take "strong man" position beside
her, haunted him. He painted it more than once, always
with the same weight of repressed emotion.

GOTTLIEB, ADOLPH 1903–74 b. US
ASCENT

GOTTLIEB'S GREAT FEAR was that the contemporary artist, living in an industrialized and overly sophisticated society, might lose touch with the ancient forms of art, the primitive expression – the symbols, myths, and legends that have nourished the imagination throughout the centuries. Living in Arizona with the starkness of the desert landscape helped him to reduce this longing for his imaginative roots to a stark simplicity. In a series called *Bursts* he refined his art to two forms against a white or pale background. First there was the circle, the sun; in *Ascent* Gottlieb has flattened it into a dull red oval, and set it in a heavy black surround. This is a threatened sun, for all its self-possession. Beneath it is the "burst", a blast of form, wildly hurling its energy into infinity. This strange, tattered shape has the clear red that the "sun" lacks, and casts a mysterious shadow. These two contrasting shapes seem, to him, to epitomize that dramatic opposition that is at the heart of life: the sun unassailable in the heavens, the sea surging wildly on the earth; the female, characterized as a closed ball, and the male exploding wildly in all directions – day and night, life and death, and good and evil.

GOTTLIEB NEVER *came to the end of playing with the strange dichotomy of being. In the end, of course, the dichotomy is subsumed in experience – it is not either/or but both that make up human existence. Reducing the essence of life to these pictograms set Gottlieb free to create art of the profundity to which he felt drawn.*

ROMANESQUE FACADE
1949, oil on canvas, 48 x 36 in (122 x 91 cm),
Krannert Art Museum, Illinois

The *Burst* series represents the climax of Gottlieb's creativity and yet in its austerity it loses something of the extraordinary imaginative richness of his earlier work. In work such as *Romanesque Facade* Gottlieb attempted to draw together symbols from various cultures – imaginary signs and forms that had a significance to him, and which he felt primitive man would understand and sophisticated man would find challenging. Gottlieb created a pictographical vocabulary with which to express what is inexpressible but essential.

ASCENT
1958, oil on linen, 90 x 60 in (229 cm x 152 cm),
Adolph and Esther Gottlieb Foundation, New York

GUSTON, PHILIP 1913–80 b. Canada
BLACK SEA

PHILIP GUSTON WAS AN ABSTRACT PAINTER, and a successful one, but he came to feel he was losing touch with reality, that he was too wrapped up in his own subjective reactions. His change from abstraction to realism lost him nearly all his supporters because it was a strange, surrealistic, half-comic, half-tragic view of the world that he decided to paint. He became obsessed with the lowly boot, and this painting, *Black Sea*, shows a great flat expanse of ocean and a great crowded sky, dominated by the majestic arch of a boot heel. The boot heel looms there in space, affirming its identity as an object; all the nails are visible, but without any pretence at a rational signification. Its importance rests on the idea of the boot heel as representative of the most lowly part of a human's attire: even lower than the foot is the boot, and even lower than the boot is the heel. This is what we press into the earth and now Guston represents it, rearing up like a Roman arch to dominate sea and sky. It is an attempt, clumsy, but deeply sincere, to enter into the philosophical reality of the material world. It is because Guston is a great artist that this attempt has produced an image both vivid and awesome.

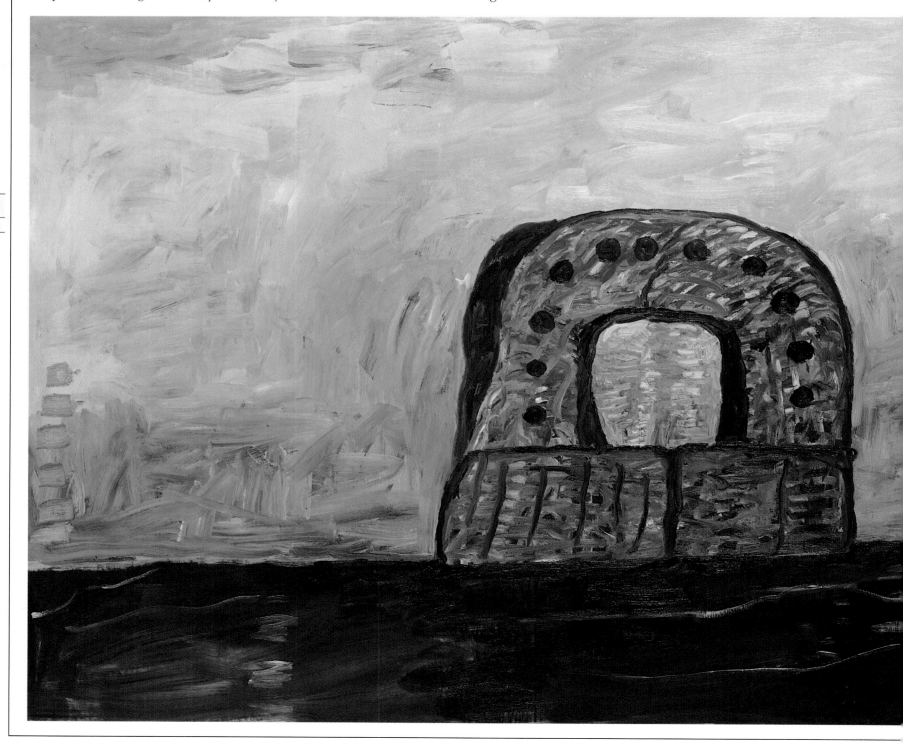

THE NATIVE'S RETURN
1957, oil on canvas, 65 x 76 in (165 x 193 cm), Phillips Collection, London

At the end of the 1940s Guston spent a year in Italy. *The Native's Return* may well celebrate his coming back to the United States. Whereas in America somber colors had often come spontaneously to his brush, memories of the beauty of Italy – its white walls, its bright, hard light, its flowers – evoked, as we see here, the palest of subtle backgrounds, all white and pink. It is rather as if color was reflecting on a whitewashed wall, deepening and becoming brighter toward the center of the canvas.

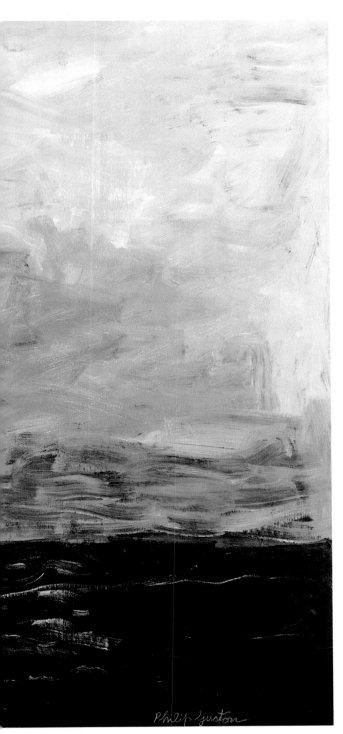

WHICH CATCHES OUR ATTENTION MORE, *this strange and threatening image or the loose, choppy handling of the paint? Guston handles his oils as if the material world itself were in flux, had no stability, and entirely lacked direction. For some reason, it is not the sea or the central shape that is most alarming, but that incoherent and very disconcerting sky.*

BLACK SEA
1977, oil on canvas,
68 x 117 in (173 x 297 cm),
Tate Gallery, London

HICKS, EDWARD 1780–1849 b. US
THE PEACEABLE KINGDOM

HICKS SEEMS TO BE PROOF of the need within humans to make art. Completely untaught, he wandered around 19th-century America sharing his vision of *The Peaceable Kingdom* (he is said to have painted over 100 versions of this image). Ironically, his need to paint the Kingdom of Peace seems to have been aroused by divisions among the Quakers – that religion so committed to pacifism. Hicks himself, we are told, was not so pacific, and it is said that the lion – always predominant in this image – was a disguised self-portrait. Whether true or not, there is immense charm in these images of a world in which wild animals and tame are at peace together and, as prophesied, are able to be led by children. To make the message quite clear, Hicks has painted four children frolicking happily among the rather bewildered beasts. Even less credible, although greatly to the artist's credit, is the scene of native Americans and colonists for whom the peace of the animals is meant to be a symbol.

THE PEACEABLE KINGDOM
*c.1837, oil on canvas,
29 x 36 in (74 x 91 cm), Museum
of Art, Carnegie Institute, Pittsburgh*

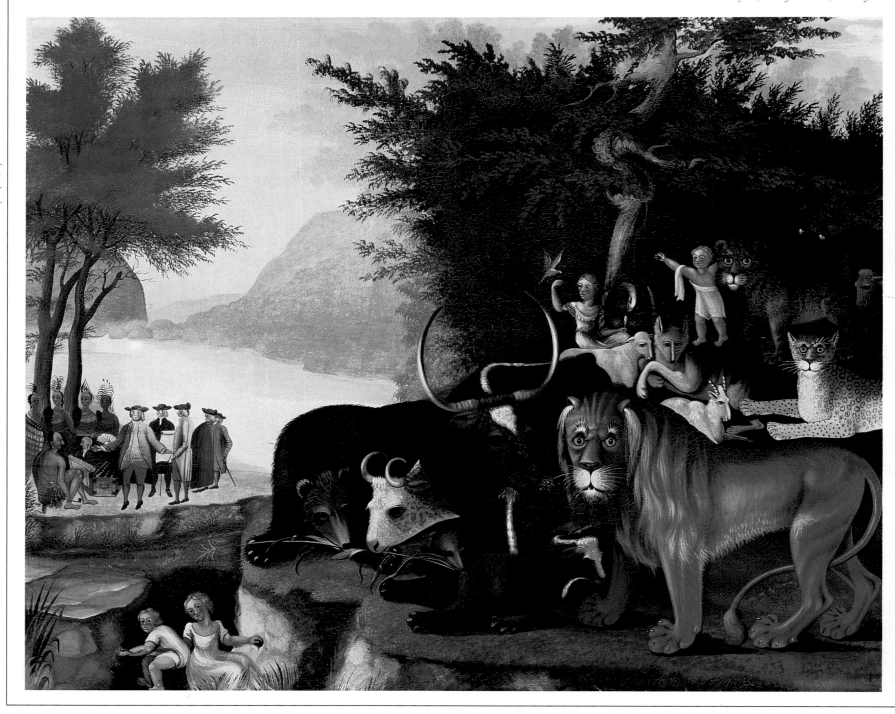

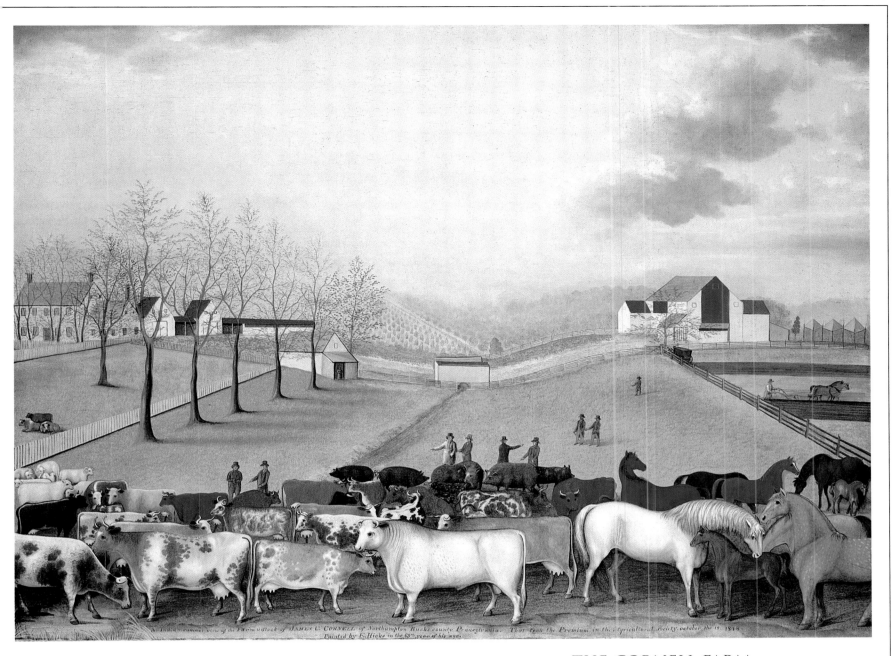

THE CORNELL FARM

1848, oil on canvas, 36¼ x 49 in (93 x 124 cm), National Gallery of Art, Washington, DC

The Cornell Farm is an image of the restfulness of order, the annihilation of chaos, and the control of the wilderness – the ideal of the early settlers. All the animals stand still and obedient, from the cattle and sheep on the left to the splendid equine family at the right. Trees stand still in obedient rows, fences are white and straight, and the farms and houses pile themselves up in obedience with the dictates of balance. The only hint of disorder is that one thing Hicks cannot control – the sky.

THE EARLY COLONIST *William Penn acted with peaceful affection toward the Native Americans, who, as we know, were soon to be dispossessed. Hicks himself seems to waver in his certainty as to the truth of this historical affection – he paints the group with a sketchy, cartoon-like quality, as opposed to the solid, richly charactered images of his animals.*

HICKS DELIGHTS *in the patterns and varieties of his animals: the curve of the buffalo's horns and the delightful bear, nibbling as he shares the maize with a theatrical cow. All this is deeply realized – the popping eyes of the tiger urged on by the child, the leopard controlling his energy, the patient goat, and a wolf looking with an interested stare at those luscious hindquarters.*

ADMIRERS SUGGEST THAT DAVID HOCKNEY is at his greatest as a stage painter. His numerous stage sets for Glyndebourne and the Metropolitan Opera House certainly have a magnificent presence and enhance the activity that takes place before them. Perhaps *A Bigger Splash* deserves pole position as his most reproduced painting, precisely because it is conceived as a stage set. Here is the California one imagines: a perfect blue sky, two faultless palm trees, a stylish avant-garde residence, and glass doors that reflect a sophisticated urban world. Central to this is the deep blue water of the private swimming pool and the splash created by the main actor, who has just dived out of view. One lonely chair sits in front of the house. The great yellow plank of the diving-board quivers forlornly in the foreground. All else is exuberant white spray, indicating a subaqua presence. It is a brilliant image of love and absence – the teasing delights of affection. The stage is set, the story is told, the invisibility of the hero is the essence of the plot. Hockney pays us the compliment of expecting us to respect his reticence and respond to the emotional challenge.

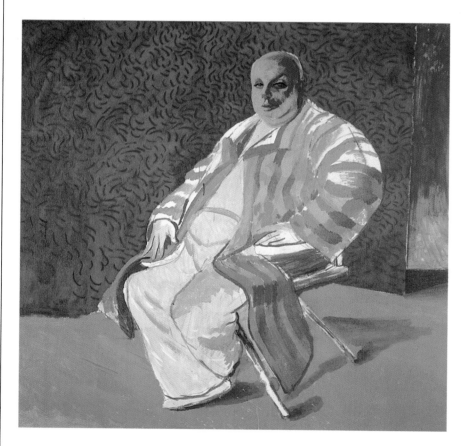

DIVINE
1979, acrylic on canvas, 60 x 60 in (152 x 152 cm),
Museum of Art, Carnegie Institute, Pittsburgh

Divine's public persona was as a large, exuberant, corseted transvestite. He was a scandalous performance artist, who relished in gossip and sending up his audiences. Hockney, as a close friend, saw beneath the performer's mask to the bald-headed, oversized, masculine presence in his theatrical, striped dressing gown. Hockney sets the figure against a jazzy backdrop that serves only to heighten the loneliness in Divine's face. This is a superb portrait, observed with both love and compassion.

> " A Bigger Splash creates a delightful interplay between the stolid pink verticals of a Los Angeles setting and the exhuberance of spray "

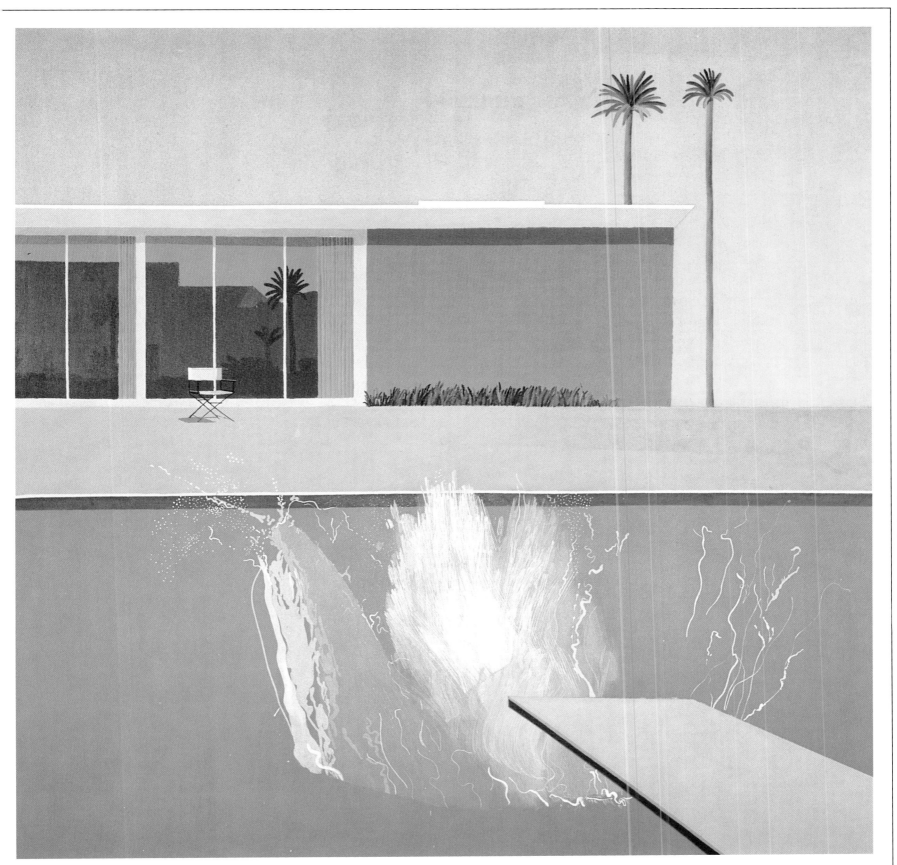

A BIGGER SPLASH
1967, acrylic on canvas,
96 x 96 in (244 x 244 cm),
Tate Gallery, London

HOCKNEY, *like his fellow Englishman Constable, paints well when he is deeply involved with the subject matter. The viewer does not see the beautiful boy who has plunged out of Hockney's life; we only witness the psychic and physical disturbance that his leaving has left in its wake.*

HOMER, WINSLOW 1836–1910 b. US
SNAP THE WHIP

FOR AMERICANS, Winslow Homer's works glow with nostalgia. *Snap the Whip* is perhaps his most famous image – the little red schoolhouse set amidst the glory of New England woods. The line of boys, vigorously intent on their game, country faces alive with effort, bodies taut, bare feet pressed into the meadow grass, is not perhaps as innocent as it may appear – the aim of the game, after all, is to snap off those who cannot hold on with sufficient energy, and the pleasure of the game is to see, as we do here, the two boys at the end falling helplessly under the momentum of their friends. There may even be another agenda – is it pure accident that the boys who are put on the end of the whip in the most vulnerable position are the boys with shoes? It is the barefoot boys who triumph. But leaving aside the narrative of the picture, one can only rejoice in the immensity and splendor of the scene that Homer sets before us: in the way that light catches the raggedness of clothes or the gleam of a shabby shirt, where buttons are lost, where a hat has fallen off, where there is a tear, and then how all this visual excitement has been set in an extraordinary stillness.

SNAP THE WHIP
1872, oil on canvas, 22 x 36 in (56 x 91 cm),
Butler Institute of American Art, Youngstown, Ohio

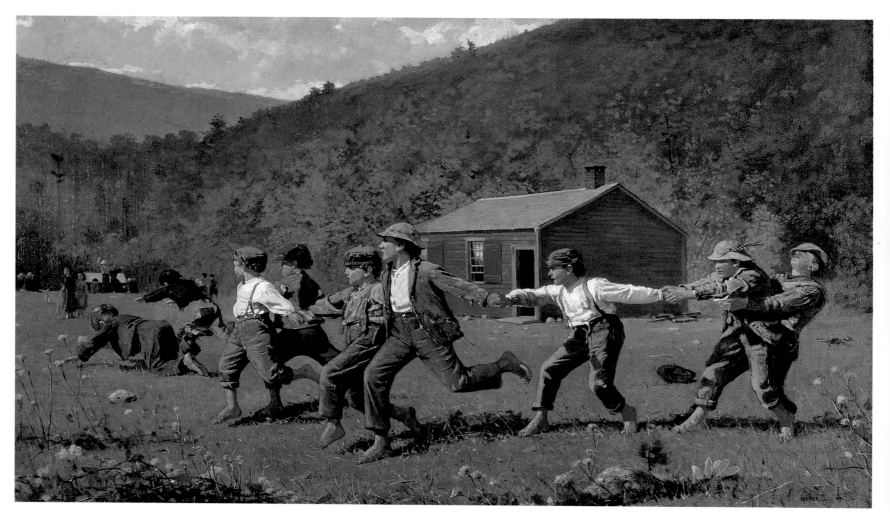

NO VISIBLE ROAD *leads us out of this enchanted hollow. The crude physical delights of rough play seem eternal here as if boyhood was all there is, and the dark little schoolroom merely a backdrop to the joy of young bodies exerting themselves to the full.*

GENERALLY SPEAKING, *Homer has not individualized the boys, but sees them as generic youth – thoughtless, happy, unaware of their privilege. Whatever the future of these barefoot boys, they have started life in the sunlight.*

ONE BOY – *the eldest, the leader, with his boots and the slight suggestion of stubble above his lip – is on the point where he must leave this carefree existence, and perhaps he tilts his head back and shuts his eyes as if to say, as Homer does, a sad goodbye.*

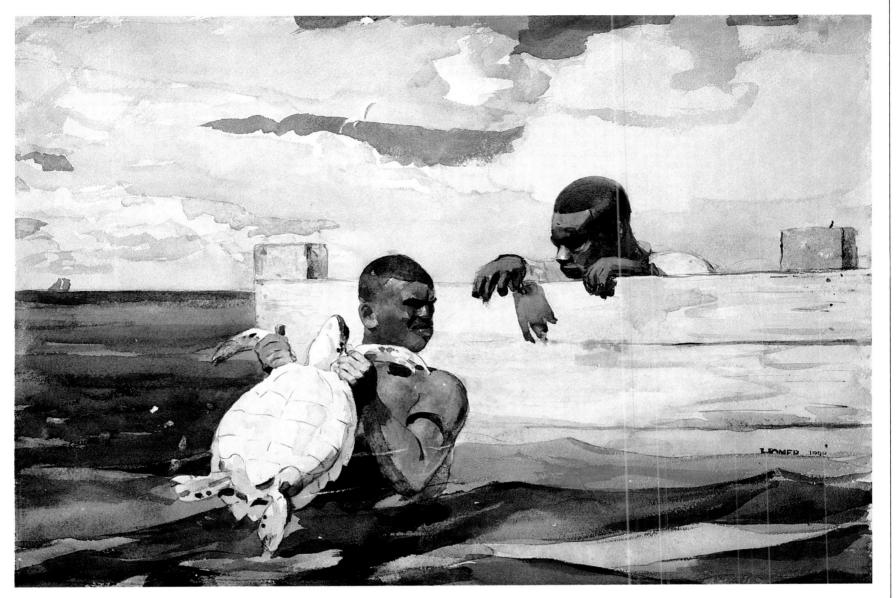

THE TURTLE POUND

1898, watercolor over pencil on paper, 15 x 21 in (38 x 54 cm), Brooklyn Museum, New York

Homer is one of the greater watercolorists in the history of painting. His art took on a new radiance of color after his time in the Caribbean. *The Turtle Pound* is extraordinary in its immediacy and its overwhelming sense of a sunlit brightness that dazzles as we look. The artist clearly found great visual pleasure in contrasting the skin tones of the fishermen against the dazzling underbelly of the turtle and the bleached wooden enclosure. Water and sky are painted with a wonderful freedom, and with rich, pure colors to produce a sense of water lifting and falling and changing hue as the light hits it.

" *Homer explored light and color within a firm construction of clear outlines* "

HOPPER, EDWARD 1882–1967 b. US

EARLY SUNDAY MORNING

HOPPER OBJECTED VOCIFEROUSLY to being characterized as a painter of the American scene and said instead, "I always wanted to do myself". Ironically, in painting himself and his own lonely image, Hopper poignantly evoked the essence of what seemed to be American urban life and the growing isolation of individuals within the great melting pot of the cities. Early Sunday morning is vintage Hopper. It is a street in what could be a small town or the suburbs of a large town. People live over rows of small shops, and each window is subtly different. The street is bathed in a brilliant, early-morning light and it is completely empty. The space is occupied by a fire hydrant and a barber's pole; of human beings there is not a trace. Nevertheless, human beings are implacably present: it is they who have chosen the varieties of lace curtains, hung the blinds, and lowered or lifted them. It is they who have opened or shut the windows.

EARLY SUNDAY MORNING,
1930, oil on canvas, 35 x 60¼ in (89 x 153 cm),
Whitney Museum of American Art, New York

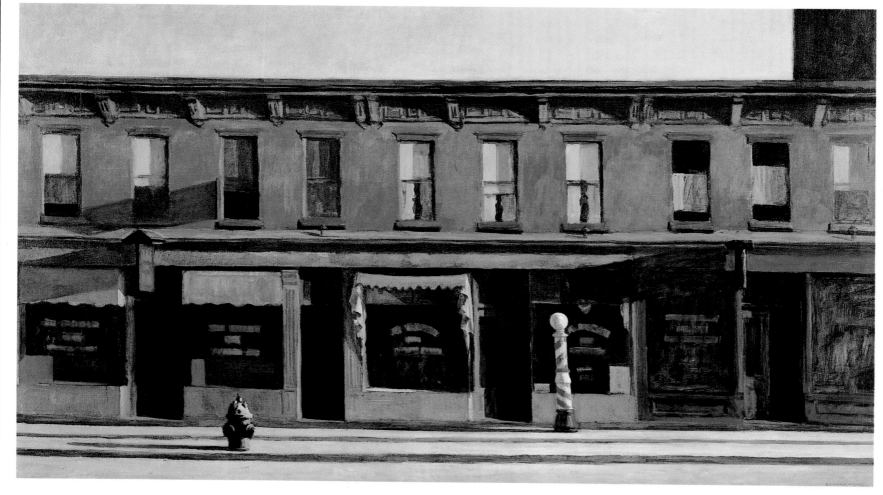

WITHIN THE SMALL CONFINES *of those box-like rooms lives are being lived, shuttered against other lives. Despite its almost stone-faced reticence, this is a picture of moral inhibition, of waste, of potential frustrated by circumstance. Light may shine but there seems to be nobody to enjoy it.*

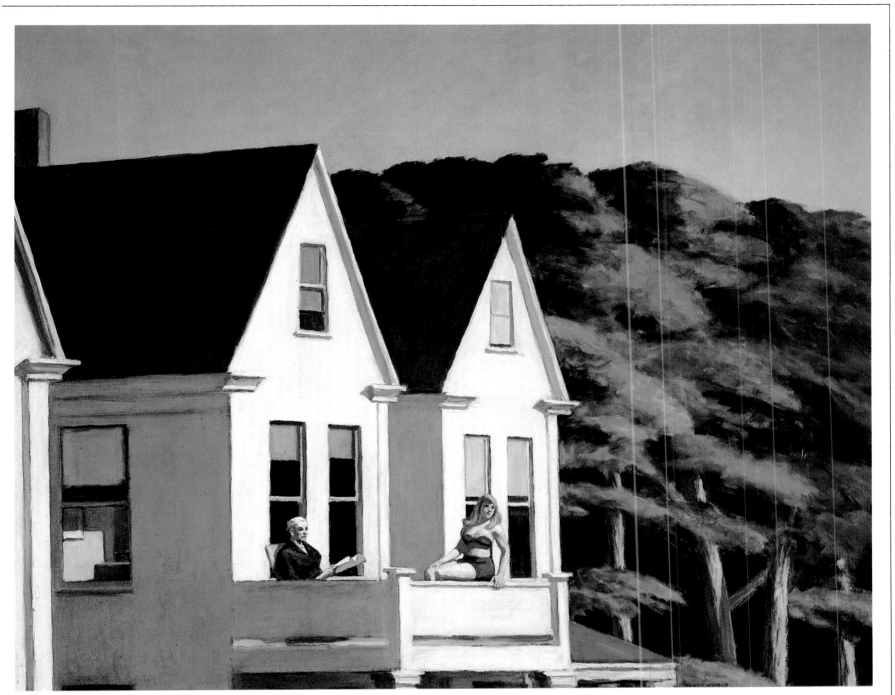

SECOND STORY SUNLIGHT
1960, oil on canvas, 40 x 50 in (102 x 127 cm), Whitney Museum of American Art, New York

Second Story Sunlight shows the neat, trim exterior of a well-kept house in the country. Again, Hopper focuses on the lonely windows and empty rooms behind them, but here there are two human beings to emphasize the mood. A beautiful girl sunbathes on the balcony and at a distance, disconnected, an older woman sits reading. Physically, they share the same space, emotionally they travel strange seas, continents apart. The older woman may be her mother or even her grandmother, but it is more than generations that separate them. Each inhabits a sealed world to which the other has no access.

" Hopper has a courageous fidelity to life as he feels it to be ... insistently low-key and ruminative "

INNESS, GEORGE 1825–94 b. US
THE LACKAWANNA VALLEY

ALTHOUGH THE PICTURE is entitled *The Lackawanna Valley*, with all its rural associations – and, indeed, we have here a strong, superb image of the countryside – the actual center of the picture, the reason for its commissioning, was the roundhouse at Scranton. The president of the Delaware and Lackawanna Railroad Company commissioned Inness to paint the roundhouse and the four lines of traffic and four engines that were the proud boast of this new-born company. Inness found these requirements irksome; clearly in his mind the ideal picture was the spreading lushness of the valley, with its background of misty hills and one lone engine chugging its brave way through the cornfields. That is still the dominant image but the original picture was rejected because it did not show enough of the railroad's holdings.

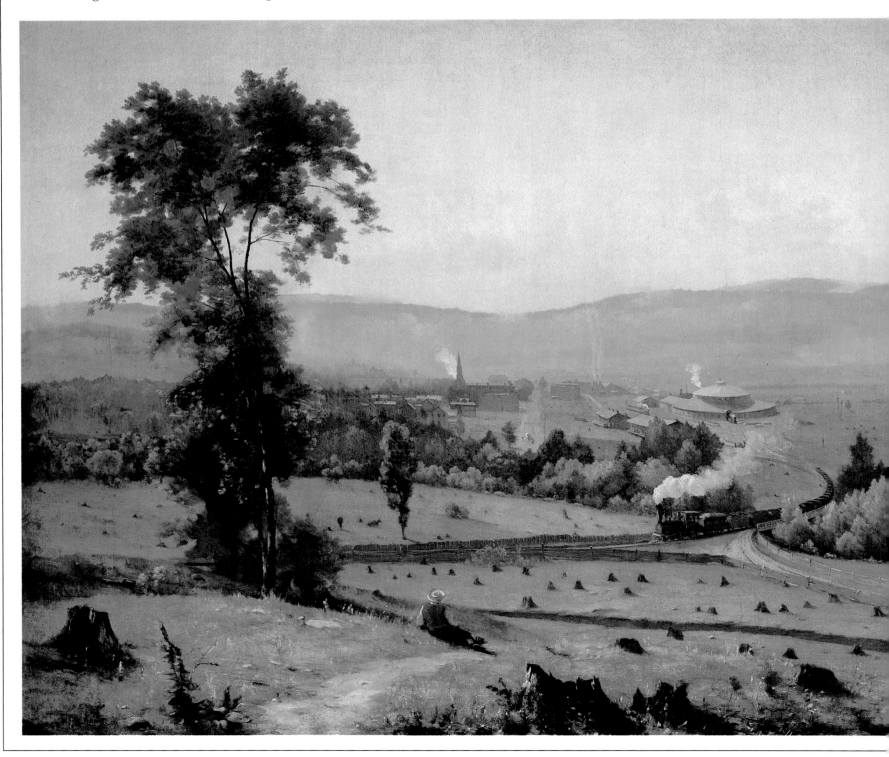

JUNE
1882, oil on canvas, 30 x 45 in (77 x 114 cm), Brooklyn Museum, New York

Inness said that the aim of art is "to awaken an emotion", and June seems to hit that button with great success. The emotion here is peace, contentment, a great feeling of security; it is a sunny awareness of the eternal foundations of life, a gratitude that we live in a world where there are still clear water, green fields, and trees. However modest, the pleasures of this picture are inexhaustible.

THIS WAS THE COMPROMISE *that Inness produced, and yet, is it a compromise? The need to hold to somebody else's line often results in a superior work of art: Inness was forced to think out his picture with great deliberation, to balance it. As such, he achieved a greater work.*

THIS IS A PICTURE *that shows both past and future: America as it had been – relatively uncultivated along the small, remote towns and villages; and America as it was about to become – the land of the railroad, and the unification and progress that that implied.*

THE LACKAWANNA VALLEY, *c.1856, oil on canvas, 34 x 50 in (86 x 127 cm), National Gallery of Art, Washington, DC*

JOHNS, JASPER 1930– b. US
WHITE FLAG

JASPER JOHNS IS A POP ARTIST in the sense that his themes are taken from popular culture. However, it is not because they interest him that he chooses them, but because he is able to disregard them. The flag, for example, appeals to Johns, not for its symbolism, but for its bare materiality, which everybody understands and takes for granted. It is a given. He has abstracted from the flag its physical shape, the familiarity of which frees the viewer from any undue interest in theme. His wish is to free art from narrative interest, from an obsession with meaning. He sees art as utterly independent and of itself – a creation of the beautiful that can only be weakened by anecdotal elements or any engrossment with the actualities of life.

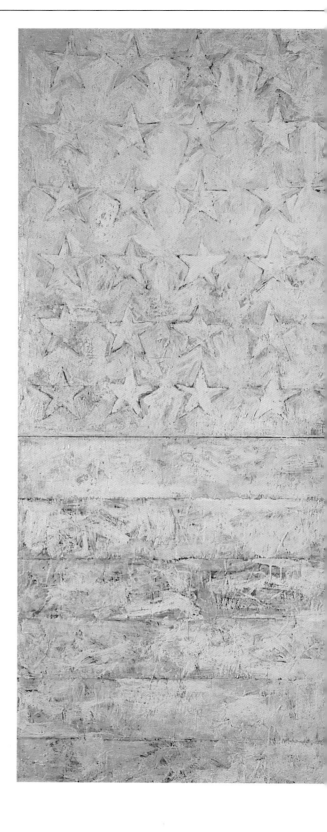

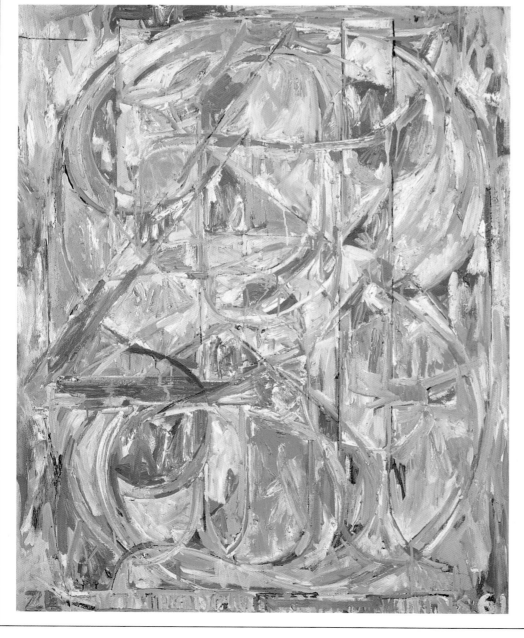

0 THROUGH 9
1961, oil on canvas, 54 x 41 in (137 x 105 cm), Tate Gallery, London

If the bare materiality of *White Flag* is without anecdotal interest, then *0 Through 9* is even more the case with a series of numbers. Johns imposes one numerical over another, and it is possible to trace out, with the help of color, the ten numbers. But his obsession is not with the shapes themselves or the color, but how the figures can be seen as abstract patternings woven together, each number allied with the others in the unity of their form. He creates a visual ensemble from elements almost invisible in their artistic interest, and yet, seen by him as compatible with dazzling pattern making.

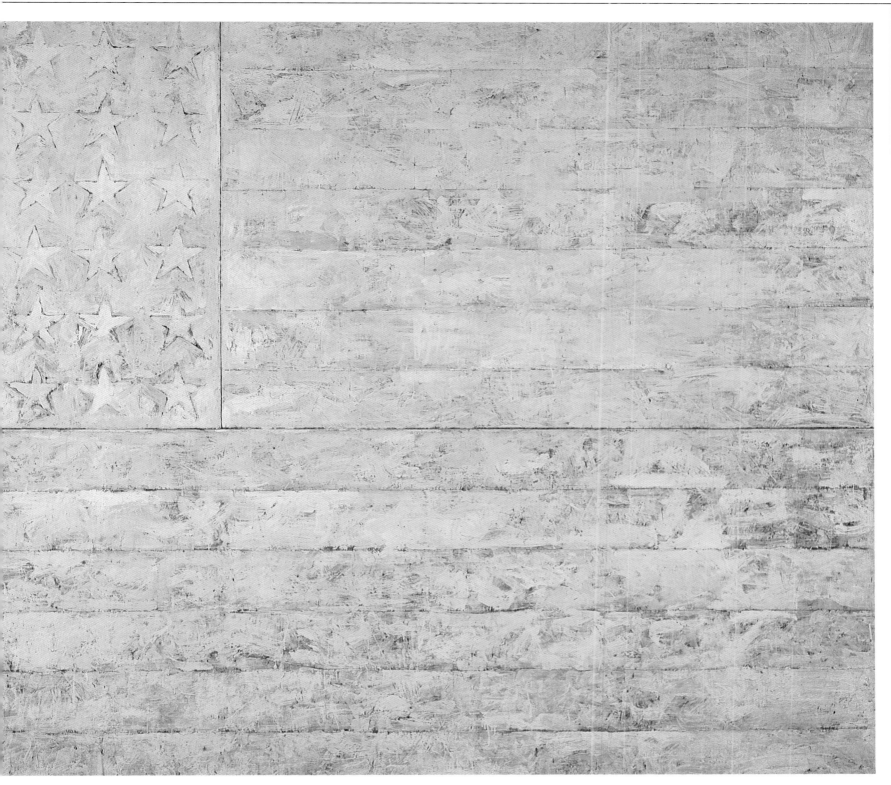

THE DEEPLY FAMILIAR FLAG, *map, or target is the foundation for the creation of something beautiful. In this encaustic and collage on canvas, sometimes the collage newspaper even becomes visible; this near transparency creates a rectangle of ethereal beauty.*

THIS WORK ABSORBS *the attention, undiluted and absolute. Johns's interest is in the creation of an art so austere and pure that it needs no support and inheres within its own making. This is what engrosses Johns – the thing in itself.*

WHITE FLAG EXISTS IN A PLATONIC *universe. The stars and the stripes accept the extraordinary grandeur of Johns's color: creamy, speckled with black, and luminous not with meaning but with the sheer factuality of the paint.*

WHITE FLAG,
1955, encaustic and collage on canvas, 79 x 121 in (200 x 307 cm), Leo Castelli Gallery, New York

KATZ, ALEX 1927– b. US

VARICK

It is always tempting to divide contemporary painters into Realists and Abstractionists, but for the artists themselves this is often a false dichotomy. Many artists seek to do both, and nobody walks this dangerous line with a greater sense of balance than Alex Katz. His work is both realistic, in that he acknowledges the existence of real things, and it is abstract, in that he abstracts from this reality patterns and simplicities that please his aesthetic sense. *Varick* is an extraordinary landscape painting. High up in the blackness of night are six lighted windows of some office block or industrial concern. Isolated as they are, we are forced to study these rectangles with interest. All have neon strips and one window is much brighter than the others; then the corner turns and illumination is over. The final windows on the left show one neon strip, suggesting variation and division of the interior space. We may assume that someone, or several people, are working inside this lit office, but what is the subject here – the windows, or the darkness of night? Which matters more, the small thrusts of human endeavor, or the great enveloping darkness of the environment? Where do we rest in such a picture?

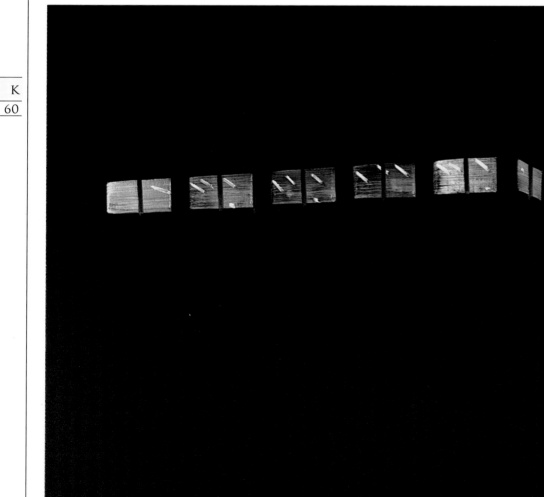

ADA AND ALEX

1980, oil on canvas, 60 x 72 in (152 x 183 cm),
© Alex Katz, courtesy, Marlborough Gallery, New York

This double portrait of Katz and his wife has that baffling quality that makes Katz so major an artist. At one level, it is almost vapid, yet how unforgettable are those faces! Again we are forced to ask, what are we seeing? No woman could be so perfect, so wrinkle-free, and no man could exist as such a minimal collection of form and color. Yet from these austere building blocks, Katz has erected a structure that forces us to accept its integrity.

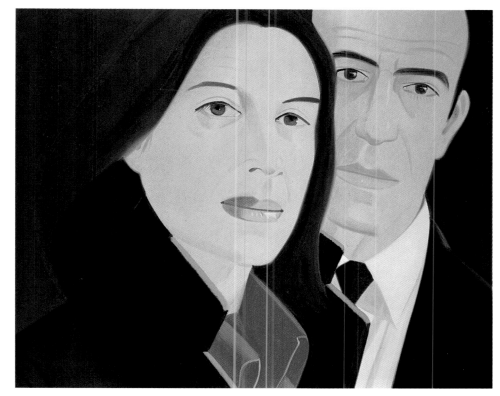

THIS STRANGE STRIP OF ACTIVITY, *high in the sky, is isolated for us by the artist as he stands outside. It is almost impossible not to think of Katz driving by, looking up, seeing this strange high strip of light, and then recreating that enigmatic image back in his studio.*

THE WORLD IS SO LARGE *and so dark; the strip of industrial or scientific activity is so small and intense. Katz poses no questions and suggests no answers. Yet, in the audacity of this vast picture – an enormous statement by the artist – we cannot but be aware of power and duty. Such a painting haunts us.*

KATZ HAS FORCED US, *by using up so minimal a section of his huge canvas, to contemplate reality in a way that is completely without the egoistic bombast of the more obvious abstract painters. The work is representational, and it is also, in its own strange, personal way, an abstraction.*

VARICK,
1988, oil on canvas,
60 x 144 in (152 x 366 cm),
© Alex Katz, courtesy, Marlborough Gallery, New York

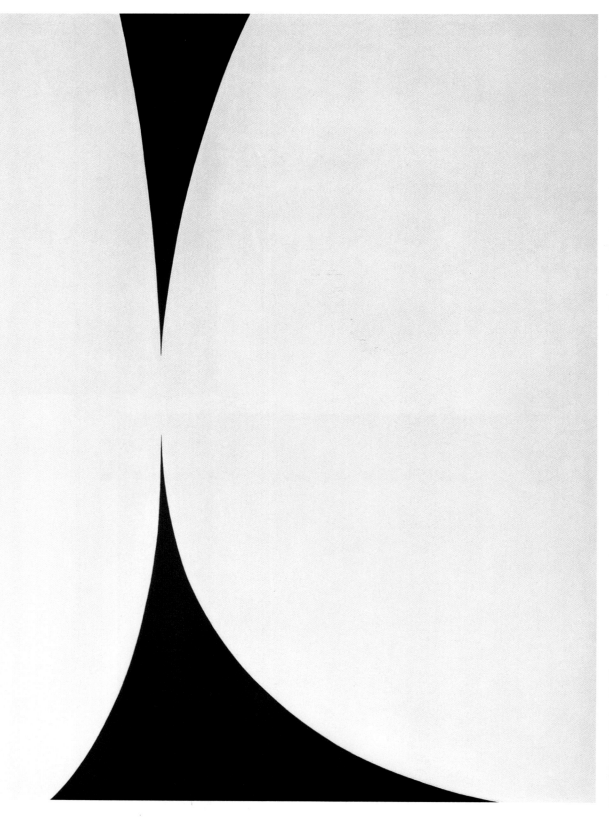

REBOUND, *1959,*
oil on canvas, 68 x 72 in (173 x
182 cm), Anthony d'Offay Gallery, London

IT IS EQUALLY POSSIBLE *to read this picture as two great*
white curves – one far more rounded than the other – which
will soon be severed, as we feel it must be, when the black
confirms its need for, and relationship with, the corresponding
black. If taken literally, one could imagine the points have met
and were now in the stage of moving away – a conclusion that,
strangely enough, we find ourselves reluctant to accept.

WHAT DO *these shapes mean? They mean what we*
make of them. In the minds of those who view them,
they arouse ideas, suggestions, memories. There is
implicit pathos, need, desire, and passion, but by leaving
such emotions implicit – by asking us to provide what
is here only intimated – clearly involves us in the
creation of this work, so strangely called Rebound.

KELLY, ELLSWORTH 1923– b. US
REBOUND

ELLSWORTH KELLY CAN SEEM AT FIRST to be a purely abstract artist, who invents shapes and colors and plays with them. This is not, in fact, the origin of his art. He has always moved from some specific shape that he has seen, either natural or constructed, which he then isolates with its appropriate color. The colored shape in itself, he feels, is a source of pleasure, an intellectual satisfaction – even an emotional one. It is this movement from observation through imaginative involvement to the final result that makes his art truly creative. *Rebound* shows us two curved triangles in opposition. The quivering intensity with which they reach toward each other may remind us of Michelangelo's great fresco, where God's finger stretches out to Adam, sparking him into life. *Rebound* has the same tension, the same implicit movement, although here it is concentrated, distilled – the lower swooping up with passion, the upper moving down with more regularity but equal force.

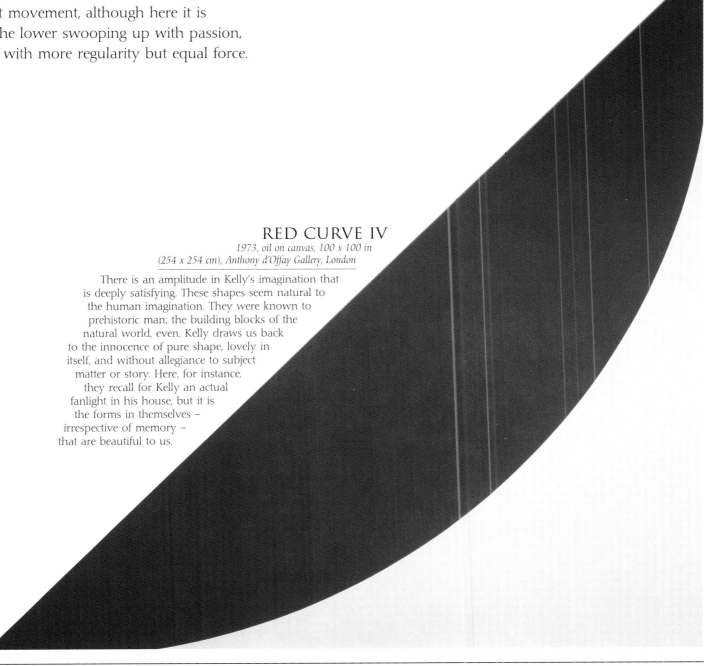

RED CURVE IV
*1973, oil on canvas, 100 x 100 in
(254 x 254 cm), Anthony d'Offay Gallery, London*

There is an amplitude in Kelly's imagination that is deeply satisfying. These shapes seem natural to the human imagination. They were known to prehistoric man; the building blocks of the natural world, even. Kelly draws us back to the innocence of pure shape, lovely in itself, and without allegiance to subject matter or story. Here, for instance, they recall for Kelly an actual fanlight in his house, but it is the forms in themselves – irrespective of memory – that are beautiful to us.

KLINE, FRANZ 1910–62 b. US
MAHONING

FOR MANY ABSTRACT EXPRESSIONISTS there was always the danger of becoming formulaic: think of Rothko's rectangles or Pollock's canvases covered with flicked and dripped paint. As with these artists, the work of Franz Kline is also easily recognizable. He too had what one could call a formula, but he used his with a freshness and a perpetual reinvention that kept him from ever becoming uninteresting. *Mahoning* is a splendid example of Kline at his strongest. Basically, his work consists of thick, black strokes against a white background, although this is a poor oversimplification of the complexity and subtlety of his work at its best. He seems to take us into something of the mystery of form – that objects exist, or can through the artist's skill be made to exist, and in existing can delight the spirit. He said the final test of the painting is this: "does the painter's emotion come across?"

KLINE'S WORK has been compared to Chinese calligraphy blown up large, but, in fact, what inspired Kline were very simple images seen in outline. Moving around New York at a time that it was expanding rapidly, he was captivated by the sight of scaffolding against the sky – the patterns it made, the sense of complexity that the maze of poles and ladders could evoke in the spectator.

TO LOOK AT Mahoning and see in it only ladders and scaffolding would be a sad failure of the imagination. Kline is creating large, powerful shapes, indicative of a greatness of spirit and of a lack of constriction (we notice how the shapes are not confined to the canvas but continue on either side). The artist's emotion does come across, but what that is remains purely subjective.

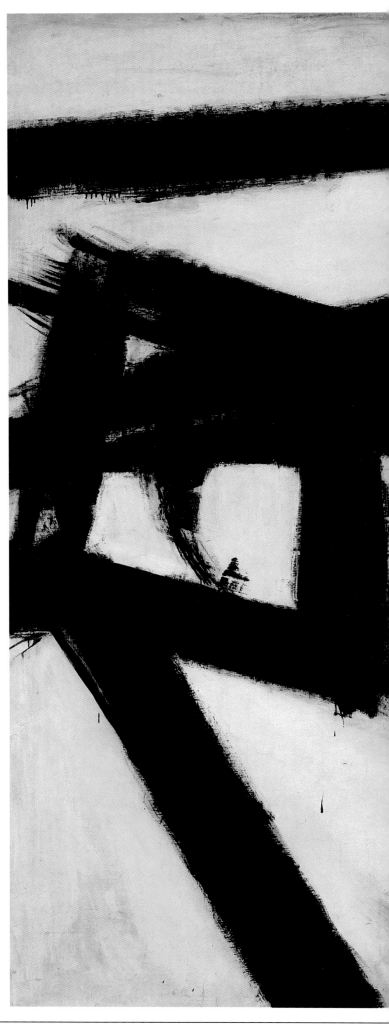

MAHONING
1956, oil and paper collage on canvas, 80 x 100 in (203 x 254 cm), Whitney Museum of American Art, New York

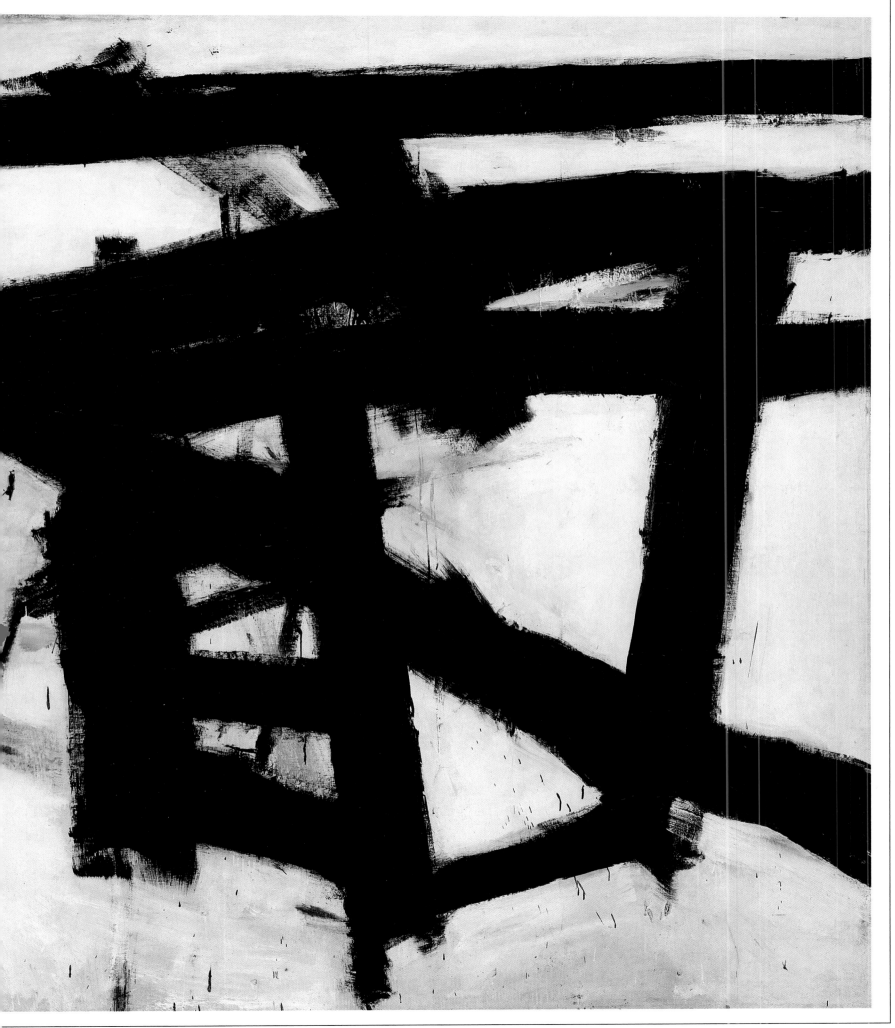

KRASNER, LEE 1911–84 b. US
POLAR STAMPEDE

LEE KRASNER WAS A GENIUS who had the misfortune not only to marry another genius but to marry one whose work peaked before her own. Artistically, Krasner was exploring in the same direction as her husband, Jackson Pollock, but whereas he had made a decisive breakthrough, soaring free of all traditional constraints, flinging and dripping paint with wild spontaneity, Krasner moved more slowly, seeking and seemingly needing more control. Pollock's violent death in a car crash seemed to liberate her, however, and while *Polar Stampede* has an uncanny relationship with Pollock's work, it remains, unmistakably, Krasner's own. In this painting, which seems to be the work of a profoundly angry artist, Krasner has almost abdicated color, attacking the canvas with great thick swathes of white and dark umber. In the crashing cascades of furious paint, she seems to suggest a long-gone catastrophic time, bringing to mind visions of the Ice Age, the freezing of the seas, and the transformation of the known world. Yet, for all its aggression, this is the work of a highly controlled artist.

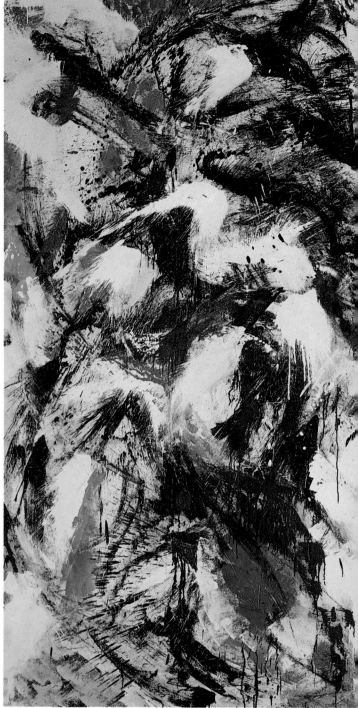

RISING GREEN
1972, oil on canvas, 82 x 69 in (208 x 175 cm),
Metropolitan Museum of Art, New York

Throughout her life, Krasner tended to paint or draw, cut up her work, and then reassemble the pieces. Even when she did not go through the stages of this process entirely, a work such as *Rising Green* comes from that same desire to create, destroy, and recreate. It is a work of surprising hopefulness. Images of flowers, the moon, and the green of springtime pass through our minds, and we notice the inexorable emphasis on the vertical, the rising.

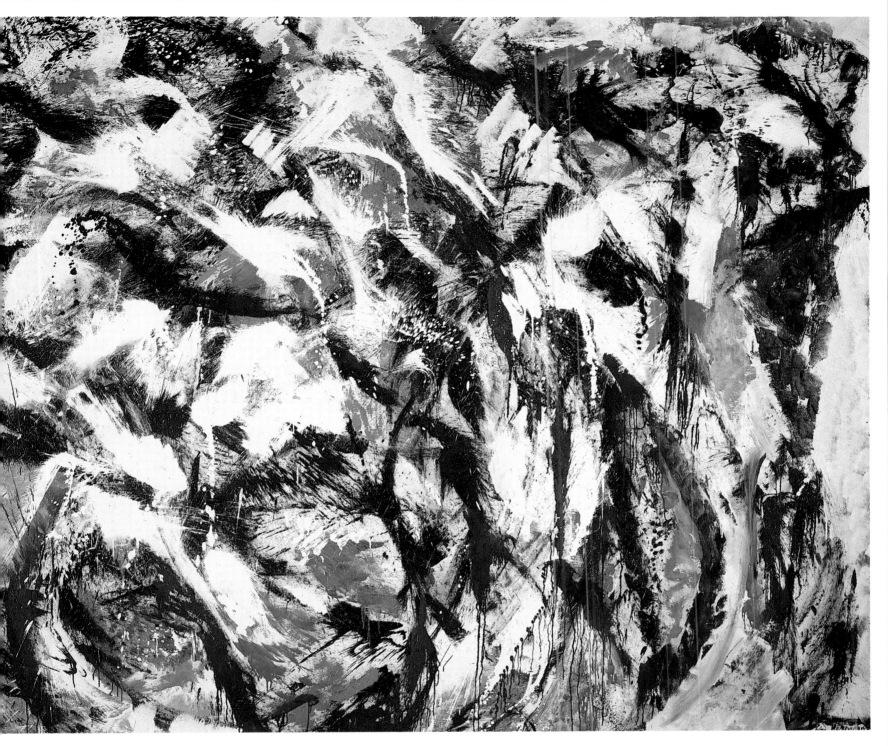

KRASNER HAS LEARNED *to accept accident, as Pollock did, but to accept it as an element to be included in the overall scheme that underlies the wild passion of such a painting. This is Krasner exploding into art, expressing in visual form her grief at the loss of Pollock, her anger at her treatment by the art world (which never once admitted that here was a major talent), and her furious determination to create regardless.*

POLAR STAMPEDE
*1960, oil on canvas, 94 x 160 in
(238 x 406 cm), Private Collection*

LICHTENSTEIN, ROY 1923–98 b. US
M-MAYBE
(A GIRL'S PICTURE)

THE GREAT REALIZATION OF THE POP ARTISTS that has transformed late 20th-century art is that even the vulgarities of our culture have their own beauty. Artists have no need to flee into ivory towers but can find engrossing images on the streets and in the supermarket. What stimulated Lichtenstein was the work of the comic book, that form of art familiar to everyone and yet unconsciously despised. He took the comic book images and blew them up to an enormous size, reworking them so that their appeal was treated and regarded with respect. There is also, of course, the saving grace of irony. But he is, most emphatically, not mocking. For all its deliberate unreality, this remains a haunting image. Lichtenstein does not pretend to show us a real woman but rather the idea of a real woman mediated through the comic book and then passed through the further medium of an ironic modern artist. It is an image that still manages to maintain its power.

"There is of course an element of nostalgia in work such as Lichtenstein's – the comic book world that is of childhood and early adolescence, with all its innocence and hopes"

FAITHFUL TO THE *comic book ethos, Lichtenstein provides us with a narrative line. The girl is distressed; she is pondering over the absence of her hero and, more than likely, making excuses. But the hero here is the artist, who is unable to leave the studio. The attitude of codified despair and the general air of abandonment suggest the traditional role of the frail woman, dependent on the might and salvation of the absent hero-artist.*

THE DISTINCTIVE DOTS – *a characteristic of the printing technique used in the production of comic books (and which would be almost invisible in the original comic) – are preserved by the artist, but only in carefully selected areas: the girl's face, parts of the background, and the window curtain. The rest is flat, solid color, striking in its power and forcing us to examine the painting with critical attention. It is hard to see how the girl relates to the actual space. Her body seems to diminish beyond the ideal oval of her face and the perfect Cupid bow of her lips.*

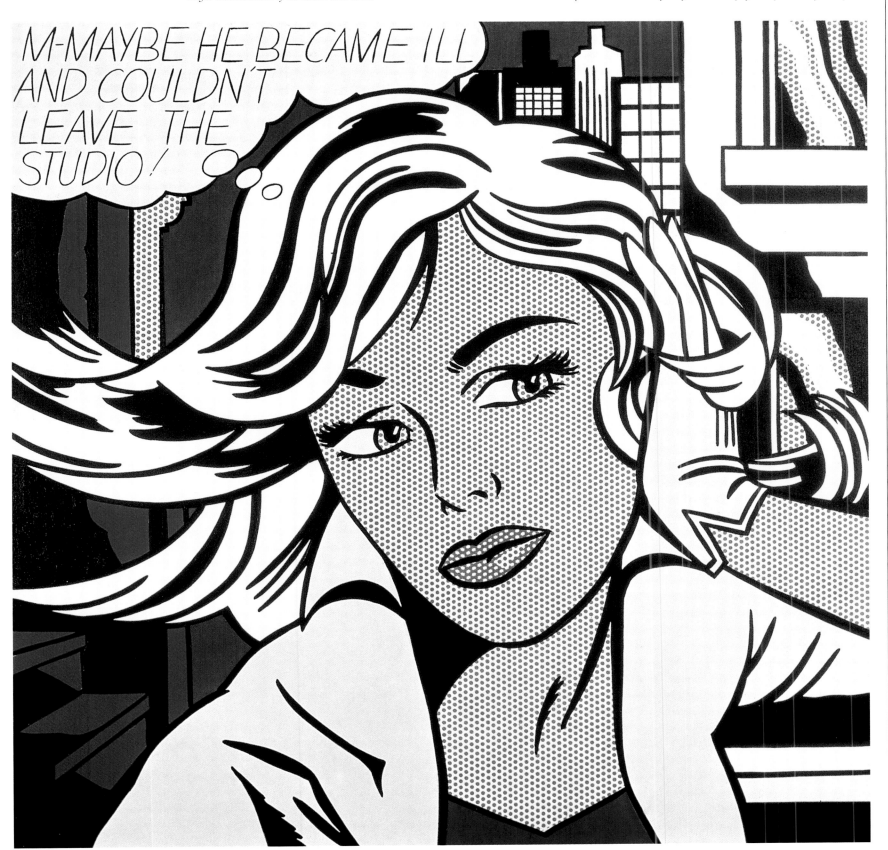

M-MAYBE (A GIRL'S PICTURE),
*1965, Magma on canvas, 60 x 60 in (152 x 152 cm),
Museum Ludwig, Cologne, Germany*

LOUIS, MORRIS 1912–62 b. US
GAMMA EPSILON

No one knows for certain how Morris Louis painted because he never allowed anyone to see him, not even his wife. He was too poor to have a studio, and so, in their small living room, he painted huge canvases that, by some extraordinary dexterity, he managed to manipulate. Having met fellow artist Helen Frankenthaler, Louis received a dramatic conversion to her method of staining paint into the canvas. Frankenthaler created landscapes with a vaguely beautiful, abstract quality. Louis used this new technique quite differently. He painted a series that we now call the *Unfurleds*, in which he allowed the paint to flow down the edge of the canvas. It took its own path, hence the resemblance of the curve and flow of nature. The role of the artist was to choose the right colors and to manipulate the canvas so that the flows remained as distinct as he desired – the paint flows met and separated as seemed aesthetically right to Louis.

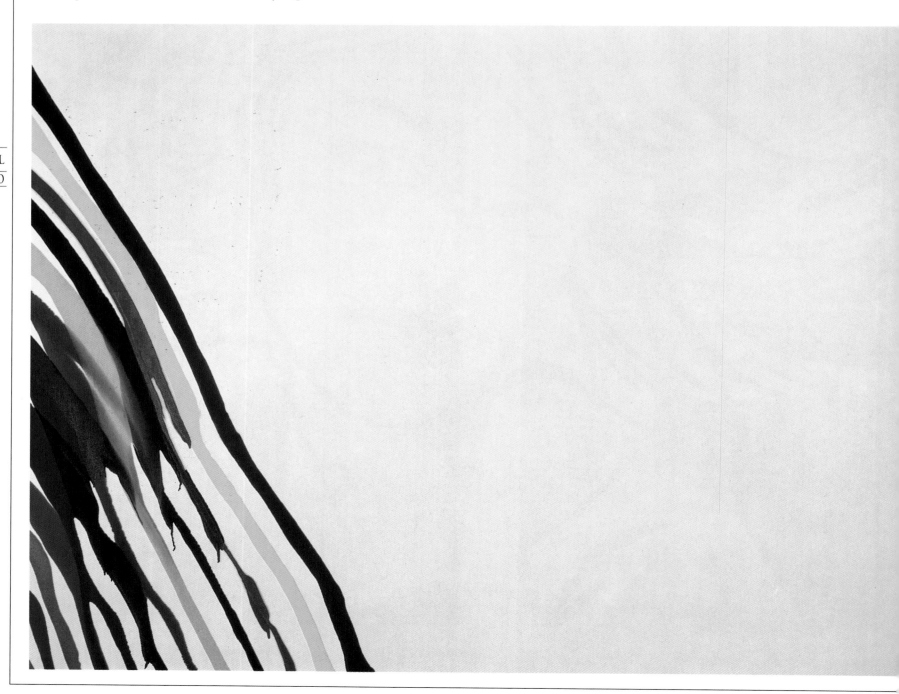

TET
1958, synthetic polymer on canvas, 95 x 153 in (241 x 389 cm),
Whitney Museum of American Art, New York

Before he embarked upon the *Unfurleds*, Louis created another series of works,
now known as *Veils*. Here, each one is differentiated from the other by Hebrew
letters. Louis has simply poured very dilute paint down the canvas, producing a
luminous veil of color that is not on the canvas, of course, but in it, the paint
having stained the canvas. Again, the art was partly to control the flow of paint,
but, even more importantly, to choose the shades that would blend and flow
together to create this diaphanous hanging veil. It seems to rise before us
with an almost mystical beauty.

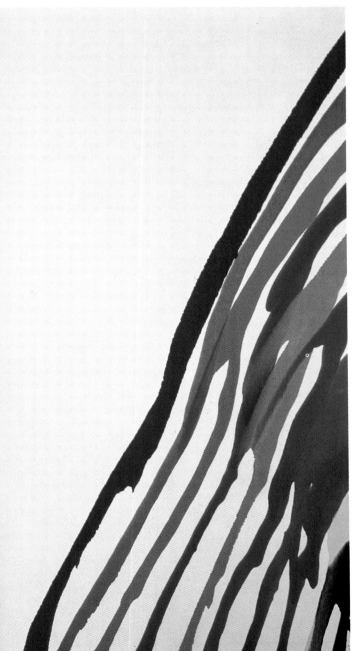

THIS WORK *was produced
using an extremely difficult
technique, in which the artist's
control over the spreading
stain was so minimal that
canvas after canvas was
considered inadequate and
discarded. The work is
extraordinary because of the
daring that allows a painting
of such a dramatic scale to be
completely empty for almost
its entire surface.*

" *Diagonal
stripes across
the canvas
create a purely
decorative
effect* **"**

GAMMA EPSILON
*1960, acrylic on canvas,
34 x 75½ in (86 x 192 cm),
Private Collection*

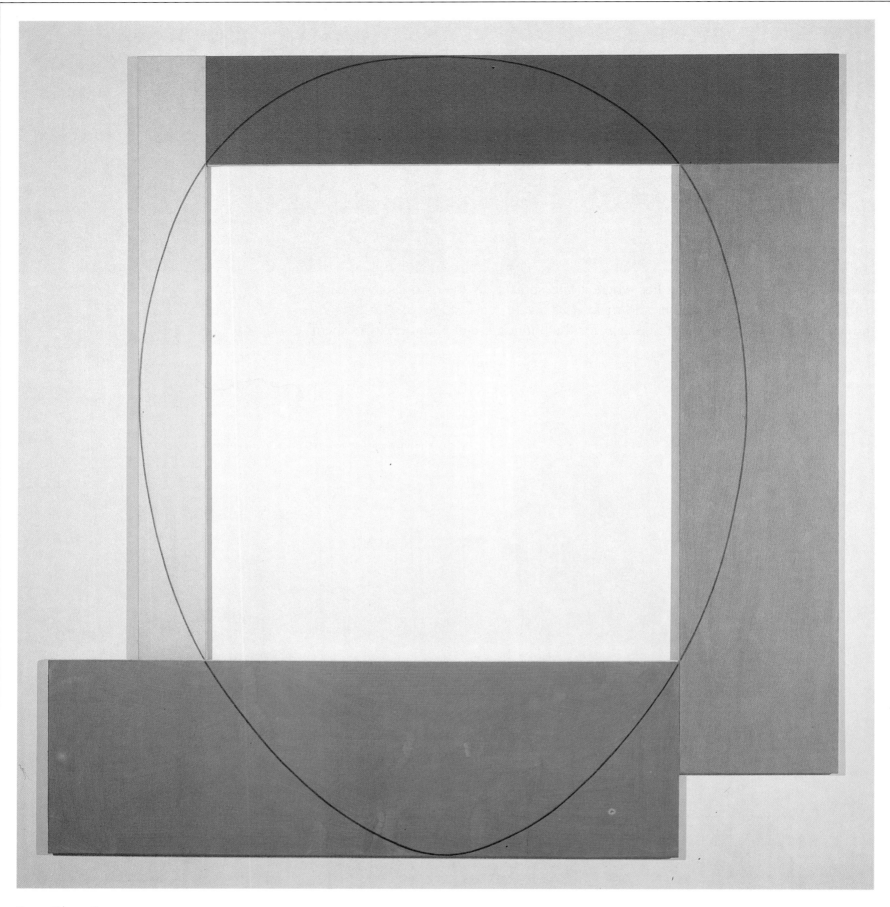

FOUR COLOR FRAME
PAINTING NO. 1
1983, acrylic and black pencil on canvas,
four panels, overall: 111 x 150 in (282 x 381 cm),
High Museum of Art, Atlanta, GA
(courtesy of PaceWildenstein, New York)

THIS IS A WORK *that seeks to fly off in all directions, to disintegrate,*
to be disunited. The four separate panels are held together by the fragile
line of the continuous oval that overlaps and unites these strong oblongs
of color – drawing our attention to the great vacancy at its center.

MANGOLD, ROBERT 1937– b. US

FOUR COLOR FRAME PAINTING No. 1

MANGOLD HAS SAID THAT HIS AIM is to make simple, direct statements. *Four Color Frame Painting No. 1* seems anything but simple and direct. It hardly seems, at first glance, to be a statement, and yet Mangold is being completely sincere. He is asking us not to regard the painting as a depiction of something but as an object in itself, as something he has created and formed through the play of color and shape. It is, in a way, pure creativity. If we pay the artist the respect he deserves and look at the work, we will find interest in the simple statement that he has created for us. He wants us to look at the four-color frame – where it fits; where it falls short; how the oblongs meet, each reinforcing the color of the other and making us aware of its "objectness," and how they are integrated by the artist's passion for the thin, clear curve that encircles them.

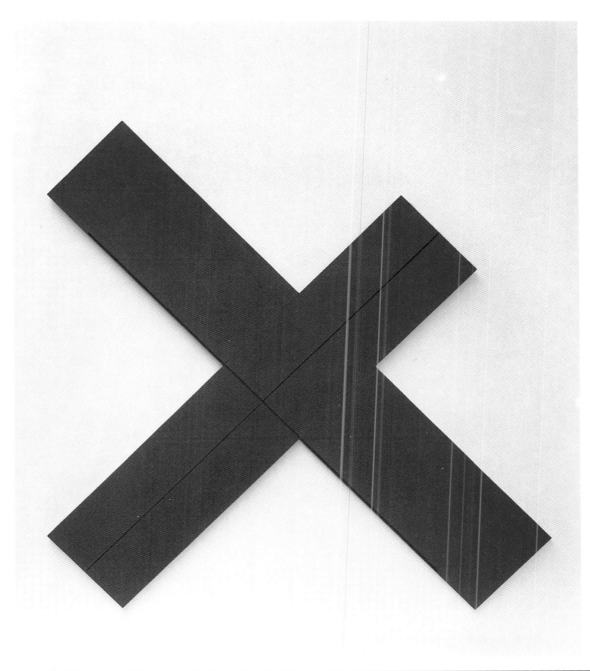

RED X WITHIN X
1980, acrylic, graphite on canvas, 113½ x 113½ in (288 x 288 cm), San Francisco Museum of Modern Art

In *Red X Within X*, Mangold opposes four red canvases, creating not a pure X but a false X. Onto the dominant form of the red X, he has drawn, with an undeviating thin black line, another cross. Eventually, we see that this black X is, in fact, the true X, which supports the red X, as stated in the title.

MARDEN, BRICE 1938- b. US
HUMILIATIO

ALL ARTISTS TAKE THEIR WORK SERIOUSLY, but not all are willing for that seriousness to be known. Brice Marden is an exception. For him, the artist's role is priestly, mediating between the divinity of beauty and truth and the waiting world. The artist is the medium, as it were, through which these great realities can come together. This sense of the sacred in no way makes his work heavy or pretentious, but it does provide an insight into a significance that is not obvious at first sight. *Humiliatio* is one of a series based upon a theological meditation about how the Virgin Mary reacted when the Angel Gabriel announced to her that she was to be the mother of God. The theologians imagined the different emotions that passed through her heart – surprise, fear, joy, resignation, and a sense of her own unworthiness. *Humiliatio* relates to the last of these emotions. The word implies an acknowledgement of one's unimportance or inadequacy for a task.

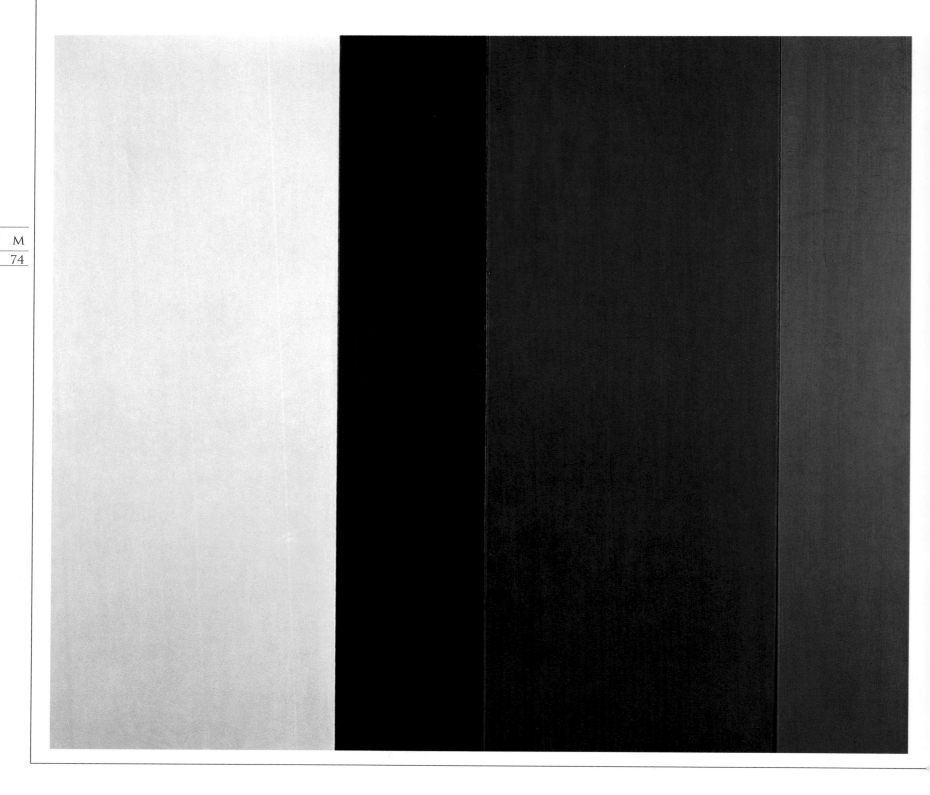

All these emotions are shown purely in color, from the very palest blue on the left, through the darker blue-black that graduates until it settles in the purplish-blue on the far right. The whole gamut of the emotions appear: innocence confronted with inadequacy, the pain of accepting that inadequacy, battling through it, and finding, in the end, a contented awareness.

HUMILIATIO is a very large painting. Marden's idea is that we do not encompass the work and control it; rather we are encompassed by it. The very size is part of the message. We are absorbed by the smoothness and depth that appears miraculously before us – a great wall of pure color that is meant to convey the artist's message.

CORPUS
1991–93, oil on linen, 71 x 53 in (180 x 135 cm), Matthew Marks Gallery, New York

Whereas *Humiliatio* seems almost untouched by human hand, in *Corpus* – the body – Marden is eager to show the precise movement of his hand. He uses an exceptionally long brush so that great control is needed as the line wavers over the large surface. We are watching the slow movements of his thought within this accepted frame. *Corpus* is not a body in any fleshy sense, but it is as if this is the texture of the nerves, the whole complex of the inner workings of the body.

HUMILIATIO
1978, oil and wax on canvas, 84 x 96 in (213 x 244 cm), Ludwig Museum, Cologne, Germany

LEAF IN THE WIND
1963, acrylic, graphite on canvas,
75 x 75 in (191 x 191 cm), Norton
Simon Museum, Pasadena, California

AN ARTIST ONCE TOLD ME *that* Leaf in the Wind *always suggests to her how a leaf flickers on a tree in almost a cinematic fashion, and that these lines are perhaps suggestive of that flicker of the film itself when it is slowed to the point where we become aware of each individual frame. Since my image has always been of a leaf floating free and wild, carried by the wind, I am unable to enter into this reading.*

AS WITH ALL ART, *there is no single interpretation, and anyone who comes with good will can have a valid response. All the critic can do is to encourage people to dare, to refuse to be put off by the apparent non-meaning of the work or by the unfamiliarity of its language, and to take time to allow it to speak to them.*

MARTIN, AGNES 1908– b. Canada, active US
LEAF IN THE WIND

AGNES MARTIN OFTEN SPEAKS OF JOY; she sees it as the desired condition of all life. Who would disagree with her? Her works have been to me a source of ever-deepening joy, and yet, with ever-deepening sadness, I have found myself unable to explain to sceptics why her work is so beautiful. Fortunately, I have realized that explanation is impossible. Agnes Martin does not deal with ideas; there are no concepts here for one to respond to; it is a work that depends upon the willingness of the viewer to contemplate. All art to some extent demands from us a surrender, an openness to what is before us. In a work like *Leaf in the Wind*, where there seems to be nothing before us but a succession of delicately-ruled pencilled rectangles on the palest acrylic background, the search for meaning is futile. The work has a meaning and will communicate that meaning in its own time and in its own way. No-one who has seriously spent time before an Agnes Martin, letting its peace communicate itself, receiving its inexplicable and ineffable happiness, has ever been disappointed. The work awes, not just with its delicacy but with its vigor, and this power and visual interest is something that has to be experienced. But with words one can do practically nothing to coax the viewer to this encounter. It is a personal matter, an experiential matter – only time enables us to respond to it.

UNTITLED No. 3
1974, acrylic pencil and shiva gesso on canvas,
72 x 72 in (183 x 183cm), Des Moines Art Center, Iowa

Whatever delight the eye takes in the color of *Untitled No. 3* will be subsumed in the looking into an experience of something deeper – the color is there to take us somewhere. Her works (and this may sound strange) are supremely functional – aids to contemplation that, without being religious, are overwhelmingly spiritual.

MOTHERWELL, ROBERT 1915–91 b. US
UNTITLED (ELEGY)

NOT MANY ARTISTS HAVE THE TIME, desire, or intellectual capacity to be philosophers or scholars, but Robert Motherwell was exceptionally gifted. Much of his intellectual energy was centered on Spain – its history and its folklore. Something about that tempestuous country moved him poetically, and he perpetually came back to the theme of the elegy. Originally seen as great symbols of grief for the Spanish Civil War (and for the poets, such as Lorca, who were destroyed in it), his elegies broadened out to become laments for all beauty wantonly brought low by human cruelty. Motherwell's elegies make use of a recurrent shape, reminiscent of the horns of a bull or the head of a matador. Behind such a form, painted in a wholly extraordinary black, lurk other colors – hints of the luminous, the scarlet of blood – that provide a context of relativity. Motherwell combines them in a crescendo of artistic fervor.

UNTITLED (ELEGY)
1988, acrylic on canvas, 24 x 36 in
(61 x 92 cm), Collection Hood Museum of Art,
Dartmouth College, New Hampshire

THESE PARTICULAR SHAPES *became almost Motherwell's trademark; forms and colors through which he felt able to express, over and over again, with renewed vigor and without repeating himself, his grief and his exultation in human tragedy.*

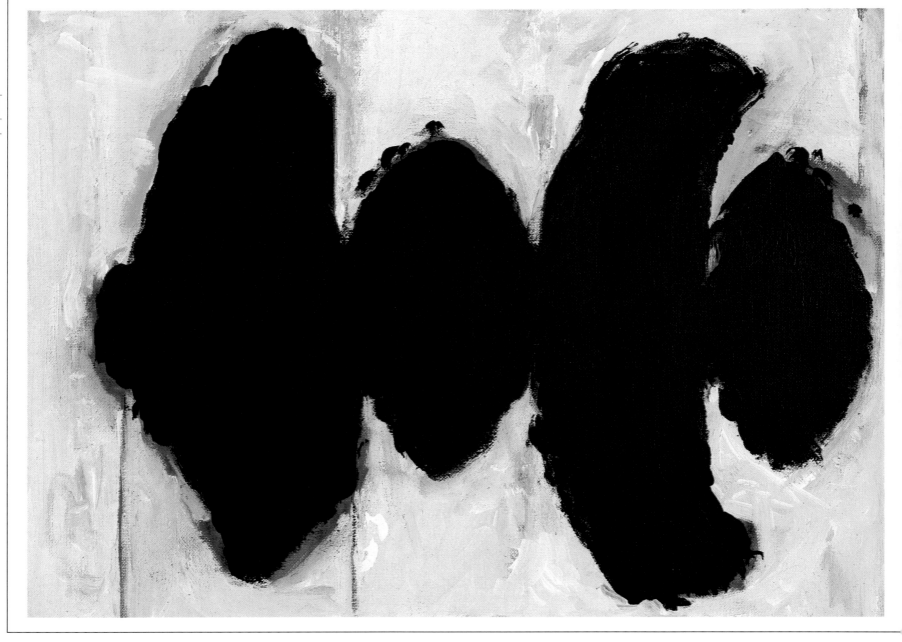

DRUNK WITH TURPENTINE No. 38
1979, oil on handmade "green" toned paper, 16 x 20 in (41 x 51 cm), Private Collection

Drunk with Turpentine is a witty comment on the way Motherwell actually painted this image. By using unprimed paper, he made certain that the paint would ooze into the turpentine splodges, and the word "drunk" suggests his delight in this controlled destruction. The image he created – at once wild and directed – has a beauty that is both undeniable and inexplicable.

NATKIN, ROBERT

1930– b. US

ISADORA

THE LONGER WE GAZE at this canvas, in which layer upon layer of color floats over the surface, the more subtleties arise from the depths of the image. The title refers to the dancer Isadora Duncan, who was killed when her long, flowing scarf caught in the wheels of a car and strangled her. Natkin does not descend to the vulgarity of explicit illustration, and it would be untrue to suggest that the thick pink line floating at the top is a reference to the scarf, or that the heavy, white oblong at the bottom refers to her gravestone. Yet, these possibilities do drift through one's mind when contemplating this picture, which rises like a memorial to the transient beauty of one of the great dancers of our century. The deep maroon of the framework, unusual in Natkin's work, forces us to concentrate on this ethereal pillar. A scarf borne aloft by the wind, an image of the pale pink beauty of the human body, a gravestone erect and translucent in the light of eternity – none of these meanings are true, and all of them are possible. Natkin is the poet of the infinite.

" *Natkin floats his colors on [the canvas], denies them, deepens them, teases them into new complexities, always with a masterly elegance* "

ISADORA
1997, acrylic on canvas,
73 x 35 in (185 x 88 cm),
The Reece Galleries, Inc.,
New York

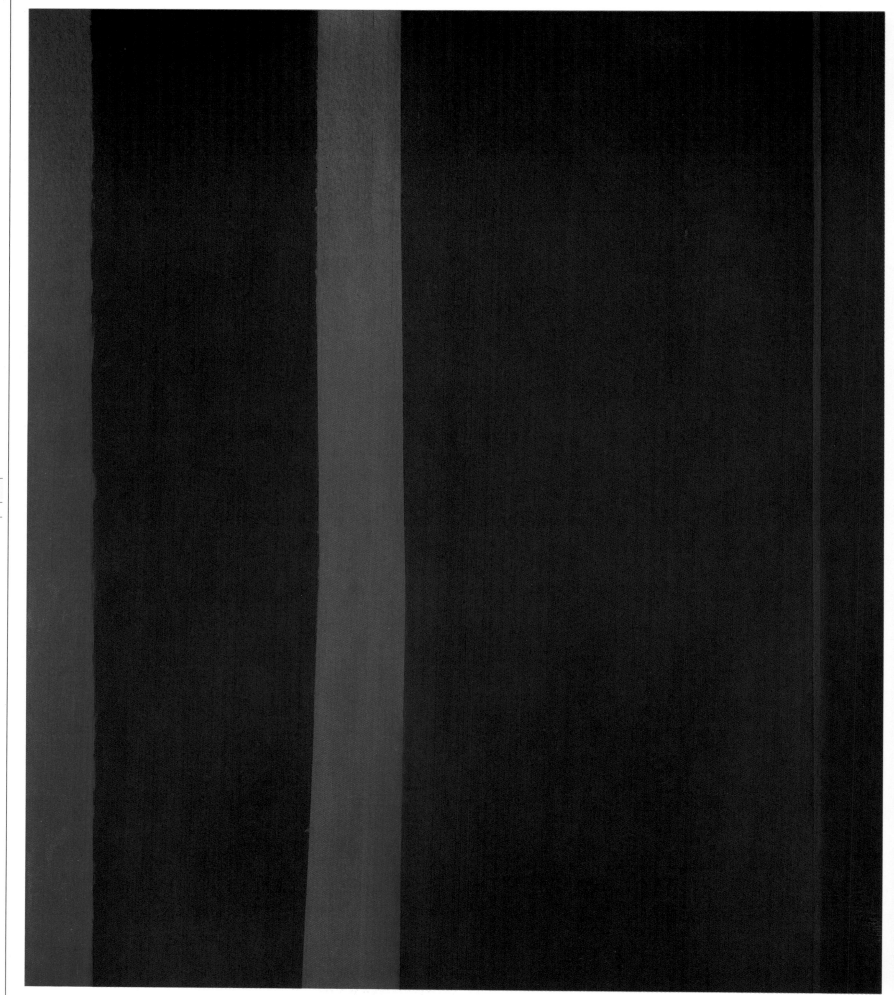

NEWMAN, BARNETT 1905–70 b. US
ADAM

BARNETT NEWMAN WAS THAT RARE BIRD – an intellectual painter who could articulate his ideas with clarity and force. The ideas can be almost spellbinding, and sometimes it is difficult to distinguish between what Newman says he is doing and what he has actually done. *Adam* is a huge picture – about eight feet high and well over six feet wide – and it is intimately related to his sense of the artist as mini-creator, linked closely with "The Creator", God. Newman, who had studied the cabbalistic writings and brooded on the mystical meanings of the Old Testament, was always struck by the primordial chaos out of which God threw order. He saw that as a paradigm for the artist, who looked at the chaos of experience and on it imposed the fertility of order. *Adam* is a work to be approached with caution. Newman was very well aware that the Hebrew word *adamah* meant "earth", and this rich earth-colored painting echoes that. "Adam" also means "man", and then again, the Hebrew word *adom* means "red", to which the artist pays tribute in the three red stripes that arrow through the great dark brown of his canvas.

NEWMAN REFERRED *to the stripe as a "zip". He would create a great field of color through which a band of light would pass, like the creating power of God, giving meaning to the work, and activating it. In Adam, the band of cadmium at the far left might, perhaps, be regarded as the creative presence of God – He who would activate the dense, inert adamah that is earth.*

ORIGINALLY, *Newman had painted only one other zip in this picture: the narrow, perfect, arrow-straight line on the far right. But later, he added a third, this time far from perfect. It is a brighter cadmium red, the line thick and wobbly, and redolent of human fallibility.*

ADAM,
*1951–52, oil on canvas,
96 x 80 in (243 x 203 cm),
Tate Gallery, London*

MOMENT
1946, oil on canvas, 30 x 16 in (76 x 41 cm), Tate Gallery, London

Newman's full-time career as a painter came relatively late, and it took him some years of searching before he discovered the style that, for him, could represent the sacred significance of art. This was the first work he considered successful. By painting a soft, nuanced wall of blue and gray, and then slashing it with a luminous white "zip", Newman felt he had solved the problem of chaos and harmony. There is an irony here, in that it is by this division – this attack on the canvas, as it were – that Newman achieved the integrated "oneness" of the painting.

O'Keeffe, Georgia 1887–1986 b. US
RANCHOS CHURCH

GEORGIA O'KEEFFE, WHO WITH TYPICAL PIONEER stamina lived to be nearly 100, is one of the great originals of American art. Like her or loathe her, she has her own take on things. As she once said, "I found I could say things with color and shapes that I couldn't say any other way." This is the feeling we get from her work, that whatever she paints conveys something intangible; it is what makes her work so personal. She is seeking not to describe but to clarify an interior meaning. She sought, for most of her life, the isolation of New Mexico, finding its vast, spare landscape a constant imaginative stimulus. Her natural tendency to almost oversimplify was encouraged by the austerity of the land and its native buildings. *Ranchos Church* has become abstracted into molten shapes of rock, while remaining true to the squat severity that we can see in photographs of the building.

RANCHOS CHURCH
1929, oil on canvas,
24 x 36 in (61 x 91 cm),
Phillips Collection, Washington, DC

HERE IS A CHURCH *without an entrance (O'Keeffe herself was not a believer), its strength quivering on the brink of liquefaction. It is windowless, doorless, and purposeless, as O'Keeffe sees it, except for the way in which the clear stone has caught the light and shadow and silhouetted itself with blunt force against the piercing clarity of the midday sky.*

WHITE IRIS No. 7
1957, oil on canvas, 40 x 30 in (102 x 76 cm),
Museo Thyssen-Bornemisza, Madrid

O'Keeffe is best known for her flower images.
Nothing annoyed her more than to have these
paintings referred to in sexual terms. She does,
of course, paint what, for a flower, are its sexual
organs, but it is the drama of the flower's
structure that interests her. Looked at just in
itself, this is a monstrous image, extraordinary
in its imaginative construct. But this is not
O'Keeffe's monster; it is nature's monster. Her
decision has been to thrust it in our faces, to
paint it so large that the viewer is forced to
come to terms with its texture and complexity.

" *Her ability to make the real become mystically unreal ... steadily influenced art for much of the 20th century* "

POLLOCK, JACKSON 1912–56 b. US
BLUE POLES: No. II

A FILM WAS MADE OF JACKSON POLLOCK AT WORK: his canvas was spread on the floor as he created a seemingly mad kaleidoscope of colors and lines. He insisted, however, that at all stages he was in control. He had gone beyond consciousness into a state of semi-trance in which the designs and patterns of what he was creating seemed to come irresistibly as he swung his arm and moved around his space. Whereas all other painting had shown us the finished image – evidence that a painter once stood before it and with his brushes created a picture – a Pollock shows us

the actual process of creating the work, the traces of the artist's physical and mental activity. This ecstatic dance was the literal outpouring of inspiration, and so we come very close, in looking at a Pollock, to understanding what it means to make something out of nothing. There is an incandescent magic about a great Pollock that has to be experienced to be believed. Perhaps it expresses for us our deepest hopes and fears about life itself – that the chaos and lack of control in which we all live will somehow, at the end, become a thing of organized if erratic beauty.

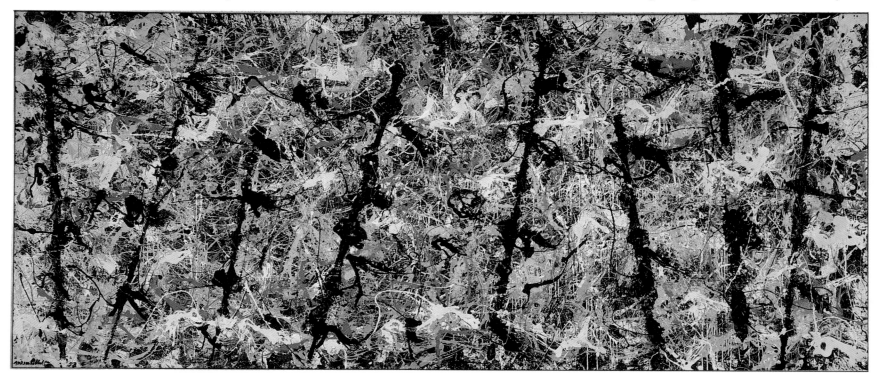

BLUE POLES: NO II IS UNUSUAL in that there is a visible structure enforced by the eight great totems that rear up and, as it were, wind the fabric of the painting around them. In their darkness and heaviness, they draw attention to the wandering freedom and the lightness of the red, yellow, and white, and the fugitive colors that show themselves, gleam, and then disappear in the vast expanse of this congested work.

PAINTINGS SUCH AS THIS were a kind of work that the art world had not seen before, and yet, with amazing speed, the marvelling viewers came to feel that the enormous electric energy here – the sheer outpouring of creative power that was yet inexplicably controlled – was something of enormous interest. To use de Kooning's famous and often-quoted remark, "He broke the ice".

POLLOCK WAS NOT TRYING to paint "something"; he was "painting". It was the activity – the miraculous interplay between the mind and the imagination, the hand and the brush, the paint and the support – that intrigued him. Those who think that anybody could do a Pollock will be interested to hear that many have tried and yet never been successful at imitating him.

BLUE POLES: NO. II
1952, oil, enamel and aluminum paint with glass on canvas, 84 x 193 in (212 x 489 cm), National Gallery of Australia, Canberra

THE DEEP
1953, oil and enamel on canvas, 87 x 59 in (220 x 150 cm), Musée National d'Art Moderne, Paris

The sheer creative energy that Pollock needed for his drip paintings could not sustain itself. Here, we see him modulating to a mood of greater serenity. *The Deep* could be the depth of the sea or the depth of the sky, or perhaps the depths of the psyche. Pollock is magically suggesting a mystery beyond. Underneath that wholly satisfying surface of creams and blues lies a completely different world, of which we are conscious only because he has opened up gaps and spaces.

RAUSCHENBERG, ROBERT 1925- b. US
BED

SOMETIMES AVANT-GARDE ART can be exasperating in its perversity. But when it works, it is transformative. Rauschenberg has been one of the great original influences of our century, and *Bed* is a staggering picture – both for the wild originality of its conception and for the pleasure that this apparent chaos of color and form provides. He took the bedclothes off his bed and poured, dripped, and puddled his paints over them. Improbable though it sounds, this activity produced a minor masterpiece. Mounted and hung on the wall, the lower half is the colorful bedspread, untouched except for an occasional dribble here and there; above, we can still see the stripes of the pillow; and from then on, sagging and bending, the furniture of his bed acts as canvas for the artist's invention. Despite the apparent confusion, the innate aesthetic has controlled every mark that Rauschenberg has made. This is not to say that he has thought out each movement in the painting, but, at some subliminal level, he is always in control and has daringly brought his work to a triumphant finish. As with all abstract art, one cannot say why the puddle of red there, the splashes of blue here, the yellow trickling over black, or the white expanse veined with yellow and purple, should please us; but, it is impossible to look at *Bed* without admiration. This, of course, is a one-off, but then is this not true of all art?

FOR SOME PEOPLE *(Thomas Hoving, former Director of the Metropolitan Museum of Art is one), this is one of the defining images of our times. It is a bed that also seems a battlefield, which in itself has profound implications. "Bed" cannot but be a suggestive word, but the suggestions here are incalculable. All the wild confusions of contemporary life and the brave attempts to control them seem somehow present here.*

BED
*1955, combine painting,
74 x 31 in (188 x 79 cm),
Leo Castelli, New York*

110 EXPRESS
*1963, oil, silkscreen on canvas, 72 x 120 in
(183 x 305 cm), Museo Thyssen-Bornemisza, Madrid*

Most commonly, Rauschenberg's method is to silkscreen diverse images to create an effect of collage. Intersecting worlds are formed, which seem implicitly to comment upon one another, their visual disparity united by the addition of painted areas. Often the title is the only key to a reading of Rauschenberg's work. *110 Express* holds our attention with its skill and its sense of speed – life being lived frantically and to the full. But any desire to impose strict logic on such a work must be resisted.

" Painting relates to both art and life. Neither can be made. I try to act in the gap between the two "

Robert Rauschenberg

REINHARDT, AD

UNTITLED (COMPOSITION No. 104)

ABSTRACT ART IS ALWAYS A CHALLENGE but few artists confront us with a starker challenge than Ad Reinhardt. Looking at a work as austere as this, it helps to remember that the artist was almost fanatically devoted to his minimalist form of abstraction. He wrote that he thought abstract painting was "the first truly unmannered and untrammelled and unentangled, styleless, universal painting. No other art or painting is detached or empty or immaterial enough." For him, painting was a pure exercise in selflessness, and even if here we can see a Greek cross slowly emerging from the darkness, this is not Reinhardt's intention.

" Reinhardt could be said to be the quintessential Minimalist "

UNTITLED (COMPOSITION No. 104)
1954–60, oil on canvas, 108 x 40 in (275 x 102 cm), Brooklyn Museum of Art, New York

TIMELESS PAINTING
1960–65, oil on canvas, 60 x 60 in (152 x 152 cm), PaceWildenstein, New York

Look as we will at *Timeless Painting*, no shape will form itself in the depth of this
canvas. The only "activity" resides in the dark borders, thickening here and
lessening there. However, if we gaze long enough at this sizable square, we will
lose ourselves in the intensity of the color, and experience the mystic freedom
that the artist intends to communicate.

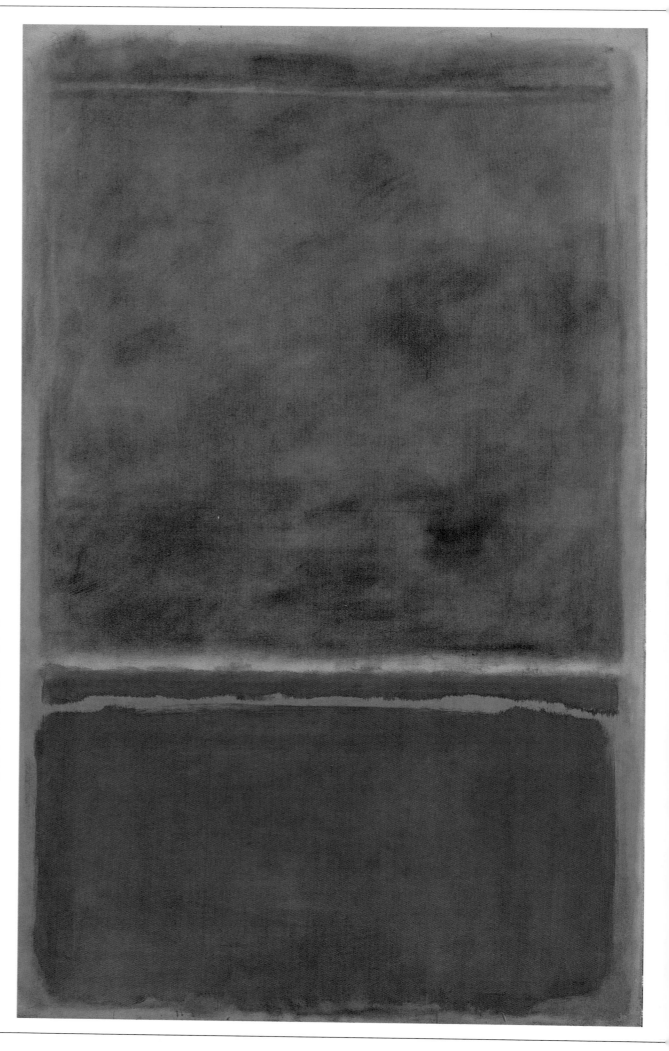

> **❝ [Rothko said] his work had an essentially emotional rather than mystical meaning ❞**

ROTHKO'S PAINTINGS *are of a subtlety that defies reproduction. Nothing is solid; everything floats away, but not into vagueness. Rothko controls and directs his canvas, and, although he insisted that what he produced was unequivocal, he was – like many artists speaking of their own work – mistaken. It is the equivocal – the different possibilities of meaning and being – that* Green and Maroon *opens up so powerfully before us.*

GREEN AND MAROON
*1953, oil on canvas, 91 x 55 in
(232 x 139 cm), Phillips Collection,
Washington, DC*

BLACK ON GREY

1970, acrylic on canvas, 68 x 64 in (173 x 163 cm), PaceWildenstein, New York

In 1970, the year he painted *Black on Grey*, Rothko committed suicide. It is all too easy to read pessimism and despair into this canvas – a critical temptation that we must usually resist. The division of the canvas is more abrupt than in his earlier work, and yet the line of division is strangely fluid. The picture acknowledges blackness, but surely as a glory – as a deep, mat solidity that harmonizes with the fragile and tender gray-gold beneath. It may speak of sorrow, but we should not necessarily read despair here.

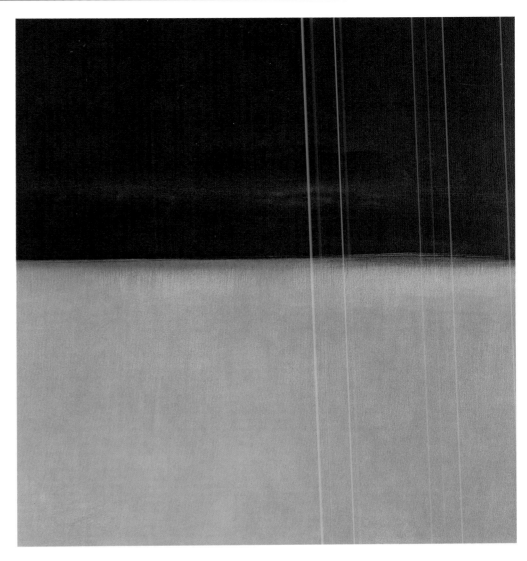

ROTHKO, MARK 1903–70 b. Russia, active US
GREEN AND MAROON

IT WOULD BE CRASS TO SUGGEST that Rothko painted to a formula. It is true that his work is instantaneously recognizable – long oblongs and squares of color floating in film upon film of chromatic luminosity. The word "formula", however, suggests the mechanistic application of a format, which is the reverse of the truth. Having found a way to express what he referred to as the "timeless and tragic," Rothko approached each canvas in a different mood and seemed to create a different atmosphere, determined to produce a different, although equally profound, effect. He was grieved – in fact, as an irrational man, he was downright irritated – when people responded with unthinking rapture to these superb harmonies of color. He felt each painting should be approached for itself alone or, if in combination with others, it must be seen as forming an ambience in which his vision of the human condition could be realized. *Green and Maroon* originally hung with three other canvases in a room where Rothko carefully orchestrated the light, dimming it so that the viewer, passing from one great picture to the next, would be enveloped by the art and forced to relinquish all ideas of rational control.

SURFACE VEIL
1970–71, oil on fiberglass, with waxed paper frame and masking tape,
22 x 19 in (56 x 48 cm), San Francisco Museum of Modern Art

RYMAN, ROBERT 1930– b. US
SURFACE VEIL

RYMAN IS THE KIND OF CONTEMPORARY ARTIST whose work can, at first, baffle the unaccustomed viewer. What, one may wonder, is he actually doing? What is the surface veil? Ryman, who is a highly articulate artist, has tried to explain, but perhaps we should not be over-quick to turn from looking at the work to reading the explanation. If we just give this work time and look at it, we may well be struck by its extraordinary and fragile beauty. It is the most delicate of works, hardly there at all, which in fact was the artist's intention. Ryman has said he really wants to paint on nothing, just to paint the paint, to show how beautiful paint in itself can be when allowed to exist without being dragooned into forming an image, or made part of a larger scenario, this is why he has used the thinnest, least obtrusive material possible – a mere surface veil in fact – in order to get the work as close to the wall as possible. His works do not exist until they are on the wall, and so have a temporal quality. Here is art floating free, on the fringes, art dependent on human involvement, as of course it always is, but Ryman makes us face it without escape.

RYMAN HAS TAKEN for the surface fragile and irregular piece of fiberglass, on which he has painted layers of delicate, almost translucent whites. He has then backed this fiberglass – not with canvas or wood or anything solid, but with just two thin sheets of waxed paper, overlapping at the center. The waxed paper support, fragile as it is, has not been backed, but has been fixed directly on to a wall with pieces of masking tape.

❝ *There is never any question of what to paint, but how to paint* **❞**

Robert Ryman

MONITOR
1978, oil on canvas with metal fasteners, 27 x 26 in (69 x 66 cm), Stedelijk Museum, Amsterdam

To get the full impact of *Monitor*, one would need to see it not just from the front but also from the side, because it has been adapted to project a few inches off the wall. Ryman wants us to look, not at what is on the canvas, but at the canvas in itself. Here is an object – the paint is clarifying it – a great rectangle moving from the demure flatness of the wall, out into our space. It is almost as if he is asking us to contemplate a flat, paint-covered sculpture.

SARGENT, JOHN SINGER 1856–1925 b. US
THE DAUGHTERS OF EDWARD D. BOIT

SARGENT HAD A WEALTH OF IMAGINATION AND INVENTION that is often undervalued. Commissioned to paint the four daughters of the wealthy Edward D. Boit family, the artist seems to have intuited something about the family relationships that called for this extraordinary composition. It is impossible to know whether he deliberately posed the four girls like this, or whether it was by their own choice, but one feels that, either way, it was in response to some emotional truth. It certainly was by his choice that they were set in this great, cavernous room, which swallowed them up in its immensities and made them seem homeless in their own home. Disunited without, one feels, a niche or a nest, they are clearly seen by Sargent as poor little rich girls; they seem lost, children without a place, without a space. There appears to be little love between them, perhaps little love for them, and they are evidently irritated by the presence of the artist. One hesitates to call it a dysfunctional family, but this is a cold, unwelcoming environment for four young women. They are dwarfed by the enormous Chinese vases, expensive objects that are clearly valued and cherished, as the daughters in their drab pinafores do not seem to be. Even the baby of the family, too young to respond to the invisible currents of family politics, sits in isolation.

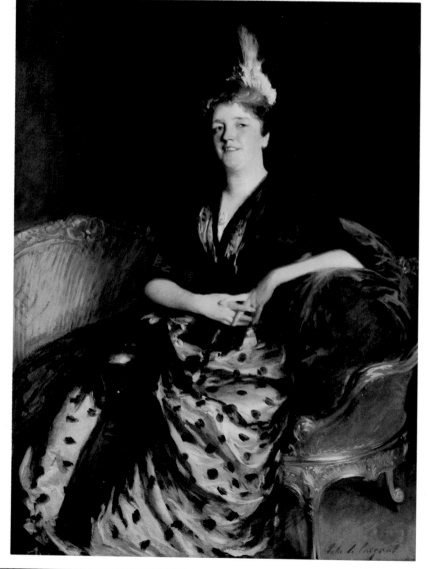

" At his best, Sargent could be as ruthless as Goya, and with something of his technical brilliance "

MRS EDWARD D. BOIT
c.1887, oil on canvas, 60 x 42¼ in
(152 x 109 cm), Museum of Fine Arts, Boston

Mrs Edward D. Boit (the former Mary Louisa Cushing) was the mother of the four girls whom Sargent had painted earlier. We do not feel that she welcomed her painting – she is putting on a face, tilting her head to encounter the artist. Her dress has the expected magnificence, as does the chair, but Sargent does not gloss over her double chin, her long nose, or her irregular teeth, and he makes a delicious nonsense of her ludicrous head attire.

THE ELDEST DAUGHTER *sullenly disassociates herself from the portrait. She stands in the shadows, and we can catch her face only dimly. Daughter number two does not quite have the courage to withdraw herself, but she presents a blank face.*

DAUGHTER NUMBER THREE *is happy to stand, isolated but at least fully in the light, and confronts the artist with a degree of implacable attention – one feels that this is a young woman to be reckoned with. The youngest merely looks with interest at the amusing man brought in to entertain them.*

THE DAUGHTERS
OF EDWARD D. BOIT
*1882, oil on canvas,
87 x 88 in (222 x 223 cm),
Museum of Fine Arts, Boston*

SHAHN, BEN 1898-1969 b. Lithuania, active US

RIOT ON CAROL STREET

ALL TOO OFTEN POLITICAL ART has so narrow an agenda that it may work as a poster but not as a painting. Ben Shahn's art, however, transcended the genre when he became incandescent with rage over the treatment of the workers in his contemporary America. Here, he shows a helpless crowd of women workers demanding fair wages. They have been blocked out from the fortress-like structure of the office, behind which men in short sleeves look out with condescension and indifference. The strange black-and-white funnels on the

building, although constructively realistic, take on a symbolic function as they peer down at the women. The great ribbon of the factory building extends almost indefinitely, with no door to admit those seeking redress or even a window that will open. Shahn, who is always on the side of the oppressed or the minority, silently puts before us the contrast of the casual bosses, secure inside their stronghold, and the agitated group outside, who, nevertheless, stand on a pavement of extraordinary beauty.

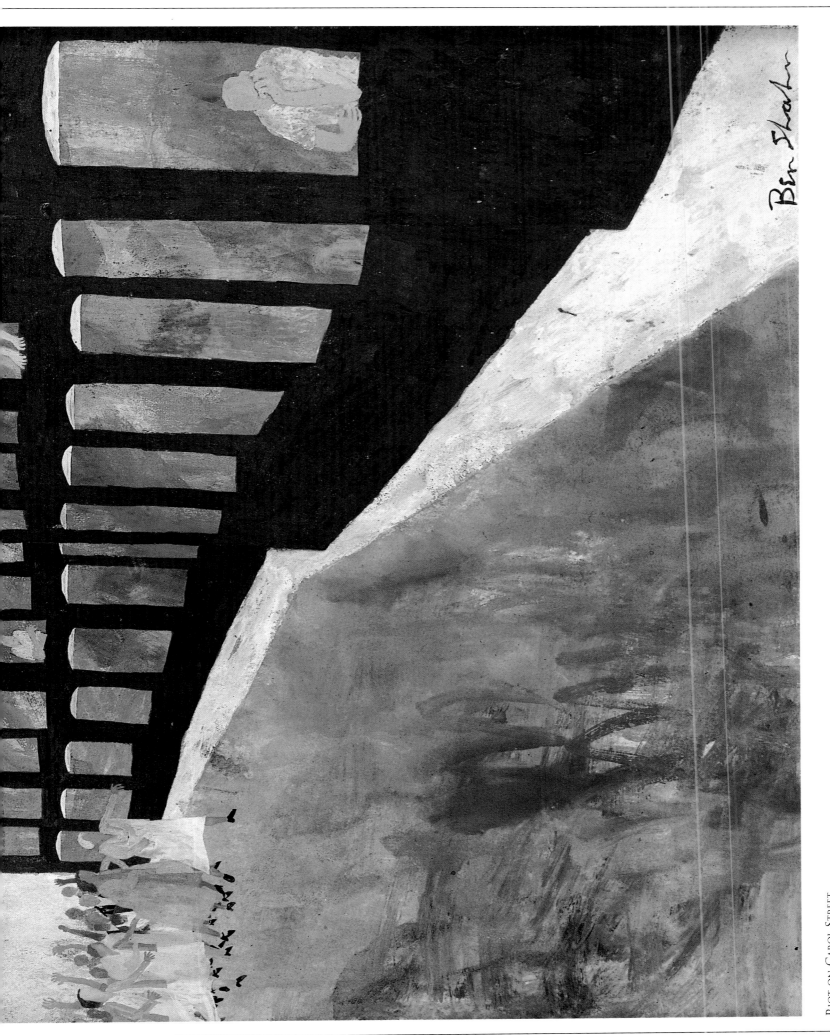

RIOT ON CAROL STREET,
*1944, tempera on board, 28 x 20 in
(71 x 51 cm), Museo Thyssen-
Bornemisza, Madrid*

AERIAL GYRATIONS

CHARLES SHEELER RESPONDED deeply to the glory of industrialism in America. Today, we look with a jaundiced eye on the huge factory but halfway through our century it seemed that the world of industry was on the way to solving all mankind's problems of want and poverty. It seemed that a glorious machine age had truly dawned, heralding the promise of perfection. Sheeler's painterly manner became known as Precisionism because of its hard-edged geometry, austerely committed to the grandeur of industrial architecture. *Aerial Gyrations* shows a massive installation in its steel reality and then in its reflections, so that every movement of those encircling rails is copied by the sun in shadow-form. As an artist, Sheeler knew that we are always uncertain as to what we are actually seeing, and yet this shadow world is intended as a tribute to the complexity and power of the real.

THE ARTIST'S EYE *responds with the most intense pleasure to those precise right-angles, those squared-off edges, those calibrated movements, that sense of an intellectual complexity that American ingenuity had fabricated and reared to its productive immensity.*

THE COLORS ARE SUBDUED, *sparse, and without nuance, as befits the certainties of science. Yet the more we look, the more there is to see. Radiant blues on the upper left, a tender pink at the lower right, that strange faint yellow-green that imitates the black bulk of the edifice, which looms up over half of the painting. This is not the tribute merely of the intellect, this is the intellect vitalized and made lyrical by what it sees.*

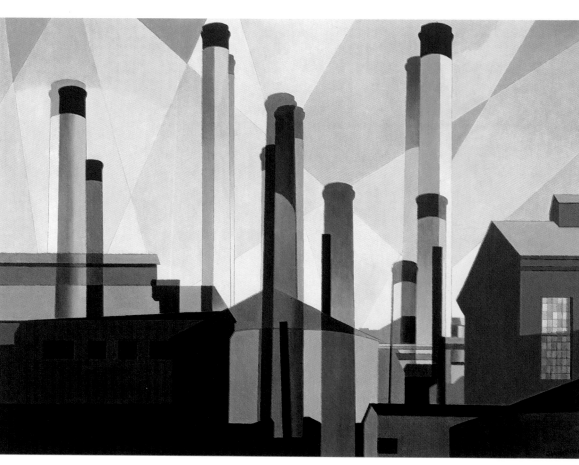

STACKS IN CELEBRATION
1954, oil on canvas, 22 x 28 in (56 x 71 cm), Dayton Art Institute, Dayton, Ohio

Sheeler saw these chimney stacks from a car and described them as a breathtaking sight. He walked around them for several hours taking photographs, and fifteen years later, using these photographs and remembering his emotion at the time, he painted *Stacks in Celebration*. He is celebrating the glory of American industry but, almost in passing, pays homage to his great hero, the painter Charles Demuth. The window on the right duplicates a Demuth window, and the overlapping stacks – semi-transparent, yet paradoxically solid – recall a Demuth painting called *The End of the Parade*.

AERIAL GYRATIONS, *1953, oil on canvas, 24 x 19 in (60 x 47 cm), San Francisco Museum of Modern Art*

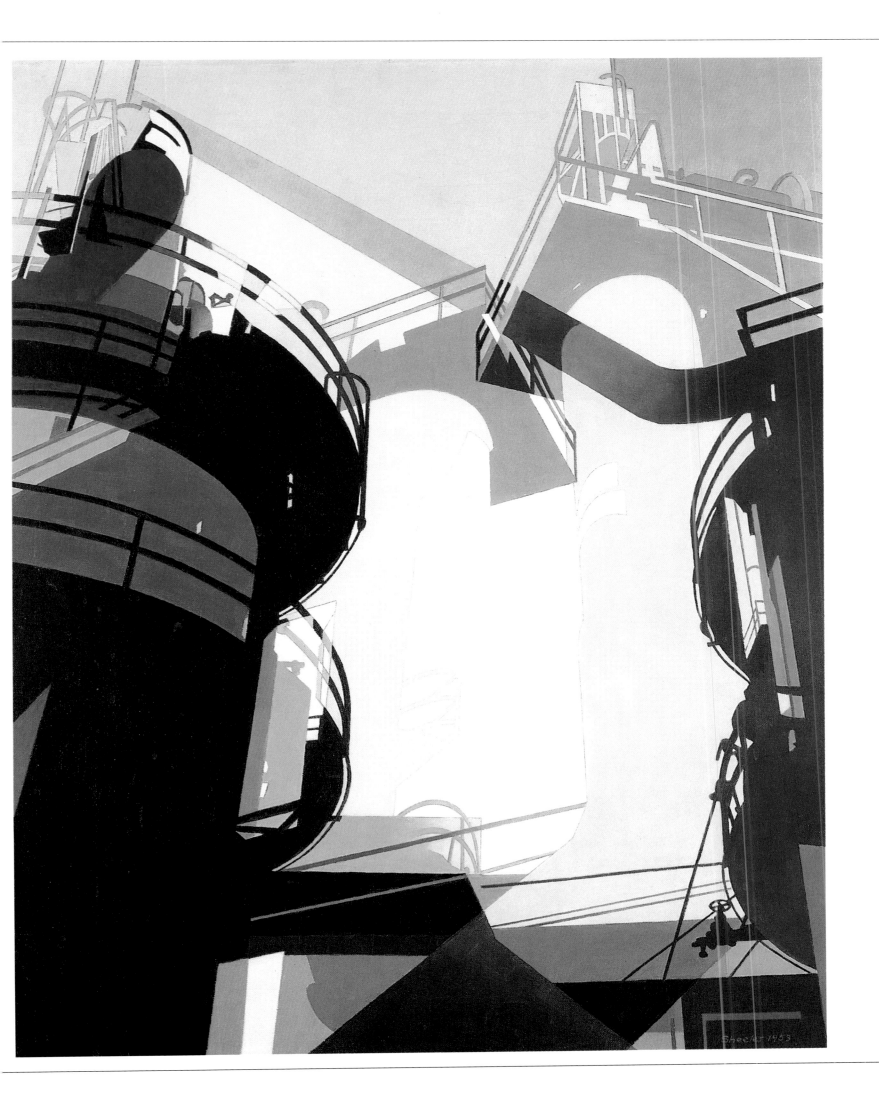

THE PAINTING'S TITLE *refers to a village in England, and is merely a method of distinguishing this painting from others in the same series. Even the width of the stripe here is determined by the width of the house painter's brush that Stella used. Although the critical intelligence can never be baffled in its insistence on meaning, it is generally acknowledged that Stella's early work offers the ultimate challenge.*

"Six–Mile Bottom *is a highly successful work, and one could claim that it implies a central order in worldly affairs*"

SIX-MILE BOTTOM
*1960, metallic paint on canvas,
118 x 72 in (300 x 182 cm),
Tate Gallery, London*

STELLA, FRANK 1936- b. US
SIX-MILE BOTTOM

YOUTH IS PROVERBIALLY DARING. Stella shocked the art world in his very early 20s by producing a form of abstraction that was more radical than anything seen before. What he did was to work out a format, as he has done here, and then, on a huge scale pursue the logical consequences of that format with ruthless precision. He painted *Six-Mile Bottom* with commercial paint, a medium that had none of the seductive qualities that are associated with oils or acrylics. This was a deliberate and considered decision – he wanted paint that would almost repel the eye, forcing the viewer to contemplate the starkness of the pattern and its execution. Frank Stella was filled with an almost apostolic zeal to divest painting of what he considered to be its trappings: its desire to be beautiful, its thrust for meaning, and its sense of significance. The semi-mystical talk of the Abstract Expressionists disgusted him. His triumph is to have created a work that is so alien to all the traditions of painting, yet which in its purity and strength is still able to satisfy the eye.

KHURASAN GATE (VARIATION) 1
1969, poylmer and fluorescent polymer on shaped canvas,
96 x 285½ x 3 in (244 x 725 x 8 cm), San Francisco Museum of Modern Art

Nine years on, Stella was still producing work that was very large and that refused to contain a meaning. But now there are brilliant Day-Glo colors, as audacious in their semi-vulgarity as the dull house paint had been in the past. For this series, which Stella felt had been inspired by the circular gateways of the Middle East, he conceived 31 different canvas formats, in which there would be three different designs: the interlaces, the rainbow, and the fan.

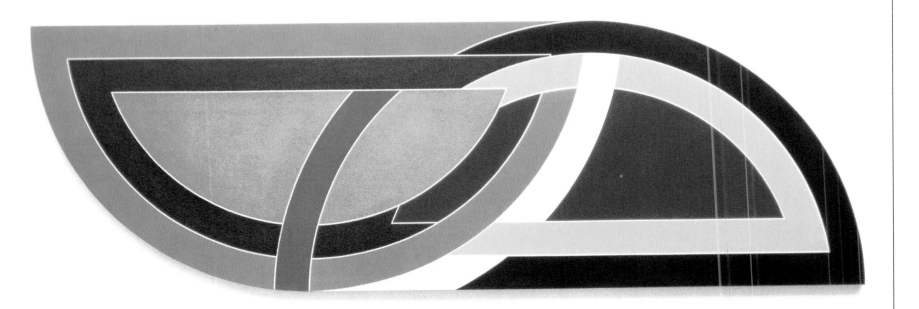

STILL, CLYFFORD 1904–80 b. US
1953

IT CAN BE DIFFICULT TO PIN DOWN CLYFFORD STILL because he insisted that all explanation was complete irrelevancy and that the paintings, if regarded calmly and without what he considered scholastic intimidation, would speak for themselves. Fortunately, the Tate Gallery managed to draw from Still a written commentary, albeit brief, on *1953*. He wrote to them: "…there was a conscious intention to emphasize the quiescent depth of the blue by the broken red at its lower edge". Looking at the picture, one understands what the artist means. That strange blur of scarlet red is not complementary to the blue, but the sheer strength of its contrast makes it behave as such, and, as the eye travels up from it, it draws from the blue its utmost vigor.

STILL HAS SLASHED *the top of the work with an interesting form of yellow, white, black, and red, and it has been suggested that we can discern in this a view of an American mountain range. This suggestion infuriated Still, who insisted that all his work was intended to be enjoyed without the slightest reference to the world of nature.*

IF WE LOOK AT *1953 purely as a great expanse of color, activated and enlivened by the incursions of the top and the bottom, we can derive from it a great deal of pleasure. Once we have realized that the search for actuality is pointless, we see that the blue is not a plain, solid, uneventful blue, but one of considerable aesthetic interest.*

> **" Still rejected references to the real world in his art and attempted to steer color from any links and associations "**

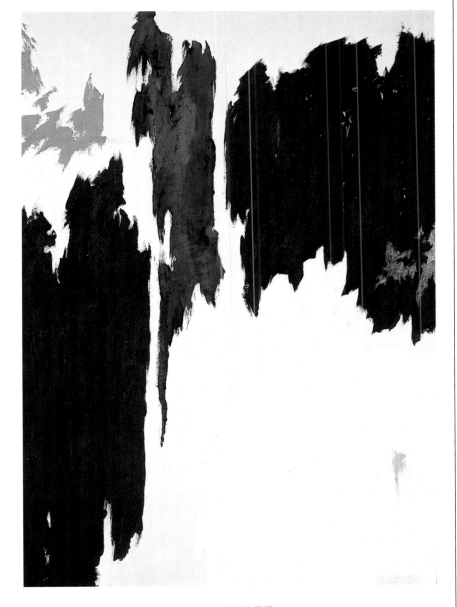

UNTITLED
1965, oil on canvas, 100 x 70 in (254 x 177 cm), Museo Thyssen-Bornemisza, Madrid

I have sometimes felt of Still, "seen one, seen them all". He always seems to adopt the same formula: a great rectangle that he covers with large streaks of impressive color. Here, he has left elements of the canvas untouched by paint, so that the strange jagged color shapes hang, as it were, in nothingness. However, I admit that my general reaction is unfair; each canvas does evoke a nuanced response. He deliberately gives us no clue in his title but there is a sense of majesty and a sense of freedom, of color floating free and independent of formal requirements.

1953
*1953, oil on canvas,
93 x 69 in (236 x 174 cm),
Tate Gallery, London*

GRANT'S RUDDY, *very English face dominates the painting, but as we look down, the grace of his pose, the dance-like movement as he slides with such ease across the ice, complements the impassive regularity of the features. All except the skater is dim and imprecise: the indistinct figures in the background lunge clumsily over the ice, clearly out of control, while far in the distance, we can just discern the shape of Westminster Abbey.*

THE WORLD HAS SHRUNK *to the space of this single human being, dominant, striking against the white radiance of an icy sky. The impression made is of a character completely in control, skating not for entertainment or relaxation, but with his mind fixed on other things. The picture, as it deserved, made a very great impression and, from then on, Stuart's career was set for success.*

THE SKATER
*1782, oil on canvas,
97 x 58 in (246 x 148 cm),
National Gallery of Art, Washington, DC*

STUART, GILBERT 1755–1828 b. US
THE SKATER

AS STUART HIMSELF OBSERVED, it is not often that a single painting establishes an artist as a figure of great aesthetic importance. *The Skater* did precisely that for Gilbert Stuart. As an American who travelled to England to study, he was struggling to keep afloat financially and a commission to paint William Grant of Congleton was his first big opportunity. At the time, Stuart was far from confident in his artistic ability to convey the essence of a personality in three-dimensional form. It is said that one day in winter, when Grant suggested that they might be better off skating than painting, Stuart agreed, and the two went off to skate in London's Hyde Park. It was only then that the artist was inspired to paint this remarkable portrait of Grant.

> **" There is a homespun brilliance in [Stuart's] work that we do not find in European art "**

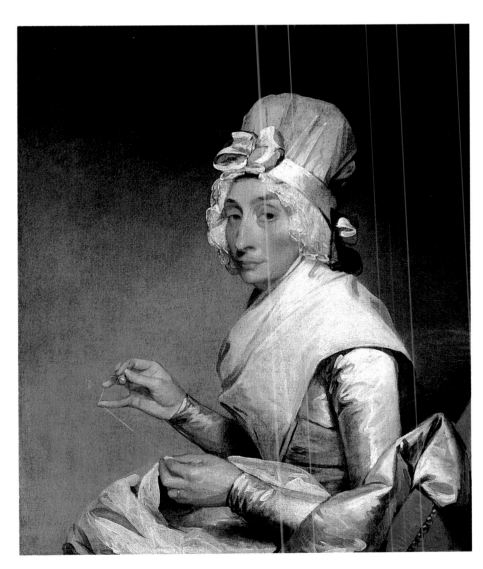

MRS RICHARD YATES
1793/4, oil on canvas, 30 x 25 in (77 x 63 cm), National Gallery of Art, Washington, DC

Mrs Richard Yates was the wife of a New York merchant – a successful merchant, as we can see from the high quality of her ivory silks – whose wife dresses with decorum. She looks out at us measuringly. She has an oval face with a long, aquiline nose and firm mouth, her upper lip faintly moustached. Stuart has devoted all his skill to setting her before us in all her integrity. It may seem extraordinary to us that Mrs Yates did not suggest to the painter that he should paint out her faint moustache. Evidently, she had a spirit above such matters, and the noble arch of her eyebrows is a true indication of a woman who enjoys finery but will not tamper with nature.

IMAGINARY NUMBERS

TANGUY WAS AN UNTAUGHT PAINTER whose imagination was seized by the Surrealist vision. It seemed to express to him the illogicality of existence and showed the world as an infinitely more complex and strange place than was generally acknowledged. Tanguy's background was in seafaring, and there is often a suggestion of marine creatures in his paintings. That may well be the sea in the background and a strange golden-black sky above it, but what makes the picture truly memorable is the great surging crowd of rocklike forms. There is a sinister power here, not so much a suggestion as a statement that reality is not what we think it is. Between the empty marshlands of existence crowd these verticals, not alive but physically present and visible; they stretch as far as the eye can see and almost hound us into retreat. We feel that these rocklike formations on either side extend to infinity, and Tanguy seems to suggest that at some time we soft, emotional human beings must come to terms with them.

IMAGINARY NUMBERS
1954, oil on canvas,
39 x 31 in (99 x 80 cm),
Museo Thyssen-Bornemisza, Madrid

THIEBAUD, WAYNE 1920– b. US
DISPLAY CAKES

IF WE HAVE TO HANG A LABEL ON THIEBAUD, it would be that of Pop artist. However, he is distinctive in that how he paints is, to him, as important as what he paints. For many years, the subject of his paintings concentrated almost exclusively on cakes and confectionery. He became, as it were, the champion of the overlooked eclair, feeling that such objects, because of their sheer banality, were wrongly ignored by artists. Yet objectively speaking cakes – with their icing and sub-structure – are interesting to the eye, and, if we are to be honest, have a strong sensual appeal. Thiebaud chose to depict this confectionery with such thickly applied and luscious paint that the painted cake – dense and dripping from the canvas – becomes very close to the real thing. The cakes are lifted up on plinths, as if they were the very epitome of consumable objects; and yet, they are removed from us, partly by the sterile white setting, and partly by the tantalizing realization that these cakes are confections of the artist and not of the pastry maker.

STEEP STREET

1980, oil on canvas,
60 x 36 in (153 x 92 cm), Private Collection

Thiebaud is very far from being a naive painter. He is capable of working in both abstract and realistic modes and is well aware of the problems of the realist painter. He talks of a perpetual dialogue in the artist's mind between what is seen and what is known: the perceptual and the conceptual. *Steep Street* calls upon our memories and our concepts of steepness.

Thiebaud manipulates perspective to give us the overwhelming impression not so much of looking but of experiencing – moving past the houses, shops, and tarred roads, as the city gives way to the countryside.

THE CAKE *to the left oozes voluptuously and compellingly. The other two are more restrained. The dazzling white cake in the center is almost a minimal sculpture – only the uneven base suggests its edibility. The cake with the cherry, again, extends and increases the anticipation of sensual pleasure.*

AS WE LOOK *at Display Cakes, we come to realize that their elevation is insecure – that they have no visible, or even suggested, means of support. They share the empty canvas with their shadows alone, as though they have sprung into being and float like angels before our eyes and mouths.*

DISPLAY CAKES
1963, oil on canvas,
28 x 38 in (71 x 97 cm),
San Francisco Museum of Modern Art

TWOMBLY HAS *structured the work on a giant letter "A" – a powerful and solid form, like that of a pyramid. It is an "A" that stands for Achilles and an "A" for alpha, the leading letter of the Greek alphabet.*

AT THE BOTTOM *of the canvas, Twombly has scribbled the title of the painting in a scrawl that is entirely in keeping with the theme of the work – the passionate vengeance of Achilles. From this base, the work rises with inexorable force. The deathly combat is portrayed as heroic and yet terrible – as a violence so absolute that it subsumes all in its path.*

VENGEANCE OF ACHILLES
*1962, oil on canvas,
118 x 69 in (300 x 175 cm),
Kunsthaus, Zurich*

TWOMBLY, CY 1929– b. US, active Italy

VENGEANCE OF ACHILLES

ALL THROUGH HISTORY, artists have been drawn to Rome, firstly from across Europe and later from America. Once there, they have become enraptured by classical culture and have remained forever expatriate. Such is the case with Cy Twombly, a difficult artist to categorize. On the one hand, his art is almost graffiti-like – scribbled in a wild flurry of lines, often with minimal color, always with nervous and uncertain tension. On the other hand, he is a deeply classical artist, drawing his inspiration from the myths of Greece and Rome. *Vengeance of Achilles* is an extraordinary example of both the freedom and discipline of his art. Here, he is referring to the hero of Homer's *Iliad*. Achilles was reluctant to take part in the Trojan war but was drawn into the conflict when his best friend, Patroclus, was killed by Hector, the military leader of the Trojans. It was only then that Achilles rejoined the battle against the Trojans. One of the most memorable events in the *Iliad* is the encounter between Achilles and Hector, which ends with violent slaughter when the spear tip of Achilles is thrust again and again into the defeated Trojan. Here, we see the spear tip, smeared red with Hector's blood.

ANIMULA VAGULA
1979, oil, graphite, and crayon on canvas, 46 x 56 in (114 x 142 cm), Private Collection

For all Twombly's wavering eye and air of indecisiveness, he is an amazingly confident artist. Against a background of wild yellow and ocher slashes is a curious caligraphy. Speaking as one notorious for the illegibility of her handwriting, I feel in a position to say that Twombly's marks do indeed seem to be writing and their legibility to be their own business. We are excluded deliberately. He has even cut the canvas as if to emphasize that his emotion is his own affair. Although Twombly is drawn to the irrational, he leads the uncoordinated, unconditioned, and non-rational of his line into a pattern that is intensely controlled.

WARHOL, ANDY 1928–87 b. US
MARILYN DIPTYCH

ANDY WARHOL UNDERSTOOD THAT ART can only be made out of concerns that personally affect the artist. He was interested in what might be described as contemporary vulgarities: he loved glamor and fame and he read the gossip columns; he reacted with prurient enthusiasm to disaster. All of these interests met in the figure of Marilyn Monroe. Here was a subject made for Warhol, and he treated her with profundity. He understood that to be famous means to be nothing – to have been stripped of one's private individuality and become the property of the world. Marilyn's images survive, but attacked, vandalized, hardly recognizable. Warhol is meditating on life and death. It seems to me that he makes an unmistakable claim to artistic significance.

USING *the impersonal medium of silk screens, Warhol shows us a hundred images of Marilyn, daubed roughly and crudely with color, emphasizing that only the image itself matters. Gradually, this image is deprived even of the false glamour of color and is reduced to the black and white of death.*

MARILYN DIPTYCH
1962, acrylic on canvas, 162 x 114 in (411 x 290 cm), Tate Gallery, London

" [Warhol was] perhaps the greatest Pop artist, whose innovations have affected much subsequent art "

VENUS LAMENTING
THE DEATH OF ADONIS
1768–1819, oil on canvas,
64 x 69½ in (163 x 177 cm),
Museum of Art, Carnegie Institute, Pittsburgh

VENUS MOURNS, *but with grace and dignity. Present also is Cupid, the little god of love himself, who understands this tragedy. To the right are the serpentine necks of the swans, which draw the chariot of the grieving Venus. To the left and right we can see the brave blossoms of the anemone, the plant that grows from the blood of Adonis.*

WEST, BENJAMIN
1738–1820 b. US, active England

VENUS LAMENTING THE DEATH OF ADONIS

WEST WAS BORN IN THE US, studied in Italy, and lived in London, where he eventually became president of the Royal Academy. He was an artist of classical decorum, whose powerful imagination was balanced by an innate sense of restraint – qualities that made him immensely popular in his own day, but less so in our own. The story of Venus and Adonis is found often in the Renaissance, usually as a theme for passionate sensuality. Venus – the god for whom every man felt desire – for once found herself under the spell of a love for Adonis. With divine foreknowledge, she saw that he would meet his death while hunting, but the young man rejected her warnings and rejected her embraces, only to end up gored by a savage boar. West has no time for the sensual – his Venus is a gracious lady of impeccable lineage and his Adonis is a slender youth whose only fault had been impetuosity.

THE DEATH OF GENERAL WOLFE
1770, oil on canvas, 60 x 85 in (153 x 215 cm), National Gallery of Canada, Ottawa

This was West's most famous picture. In a stroke of avant-garde brilliance, he managed to turn the contemporary tragedy of the death of Wolfe into a historical event. It is, of course, completely fanciful in its details. The hero dies as heroes do on a stage, and the officers who surround him with such dignified grief were, in fact, elsewhere at the time. They are said to have paid a hundred pounds each to be included in this picture and thus immortalized.

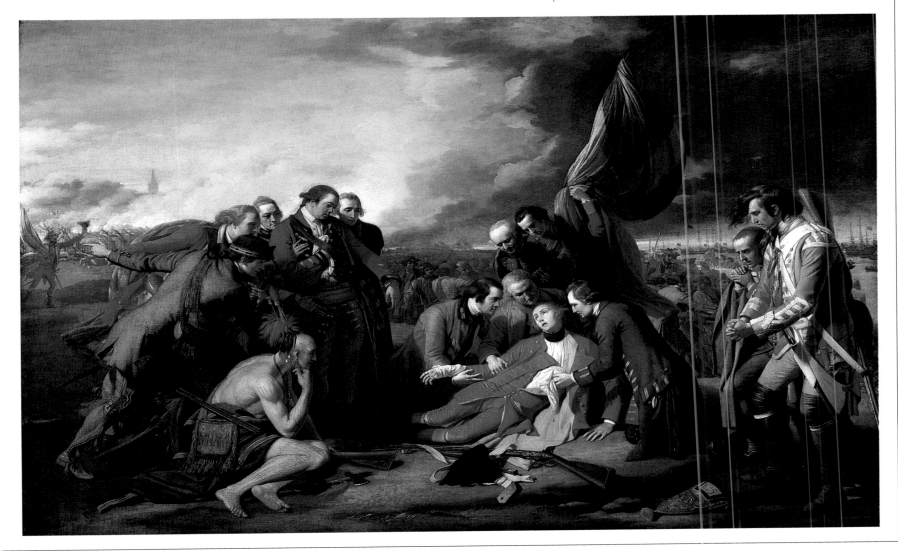

WHISTLER, JAMES 1834–1903 b. US
HARMONY IN GRAY AND GREEN: MISS CICELY ALEXANDER

HAVING YOUR PORTRAIT PAINTED BY WHISTLER was not easy. He was a perfectionist and demanded hours upon hours of patient sitting or, in this case, standing. We can understand why young Cicely has a rather disgruntled expression, but it was worth the wait; this is a superb illustration of the fragility and sweetness of youth. Cicely is as fresh and delicate as the daisies springing up at her side, and like them she must accept the ravages of time. The same fragility of beauty is symbolized by Whistler's favorite motif of the butterfly (they hover above Cicely's head, and his famous "butterfly" signature can be seen on the back wall). The brightest color in the picture is her face, with those rosy, pouting, and unhappy lips. All else seems to float upon the canvas: whites, grays, blacks, so subtle, so nuanced that they seem to dissolve and reform themselves before our very eyes. Perhaps "infinity" – infinitely beautiful, infinitely graceful, infinitely vulnerable – is the word that best sums up this picture.

NOCTURNE: BLUE AND GOLD
1872–77, oil on canvas, 27 x 20 in (68 x 51 cm), Tate Gallery, London

Whistler felt an affinity with the music of Frédéric Chopin and was convinced that the magical effects of Chopin's Nocturnes could be paralleled in paint. Here, around the form of old Battersea Bridge, is an efflorescence of golden fireworks and the scattered golden lights of misty London. We are meant to be affected, not by the details of the work, but by its whole harmony, to be moved as we are by music.

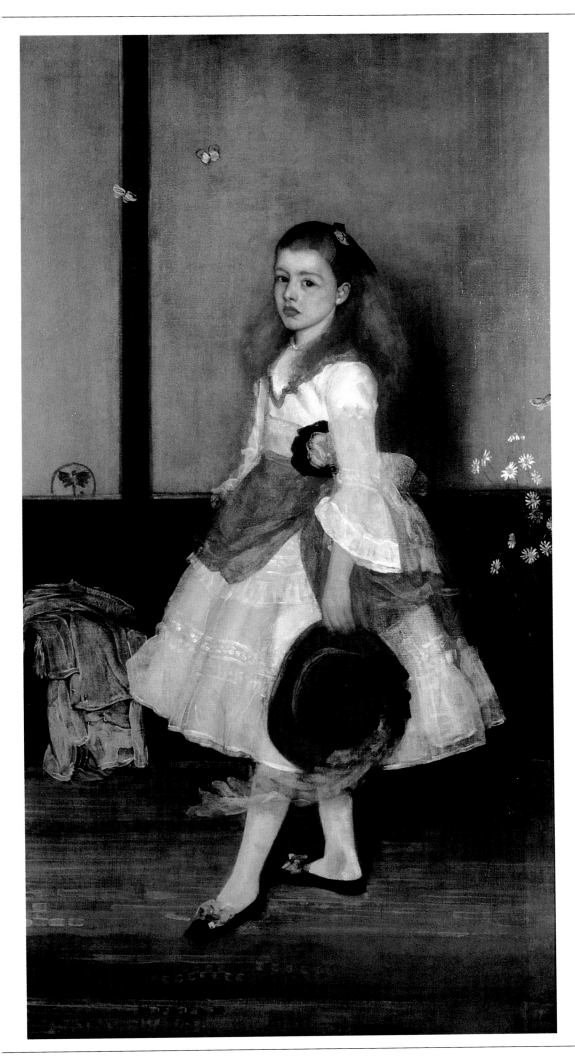

" Whistler is at his best when he plays with shapes and colors and it is their intrinsic interaction that delights him "

HARMONY IN GRAY
AND GREEN: MISS
CICELY ALEXANDER
1872–74, oil on canvas,
75 x 39 in (190 x 98 cm),
Tate Gallery, London

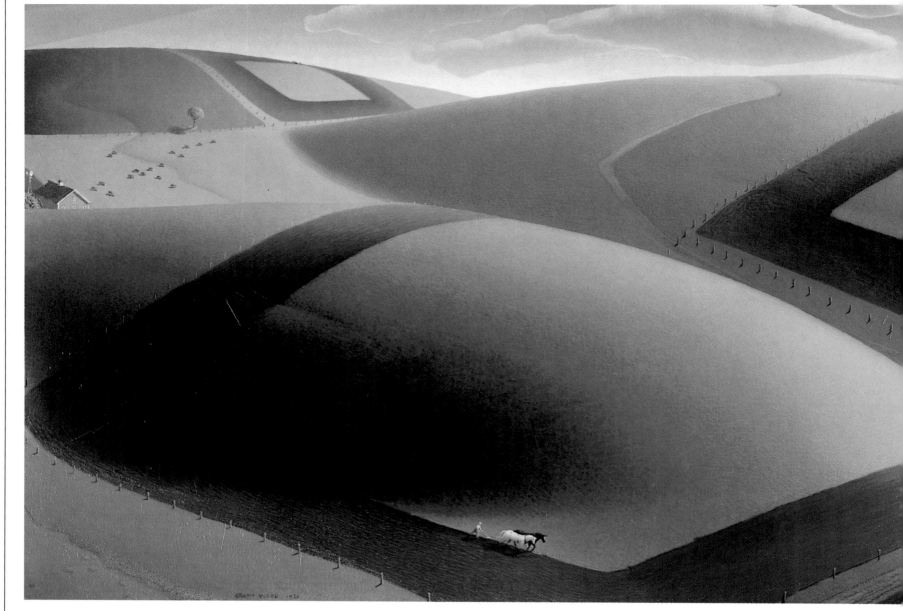

EVEN THE LITTLE HEDGEROW *on the right runs in an order of rigid regimentation. The very clouds have been disciplined and float like airships across the bright sky. The discipline of the artist echoes the discipline of the farmers. The small figures, laboring with their horses, are taming nature, turning what would be the wilderness into a fruitful and organized prairie.*

BY LOOKING DOWN *on the scene as though from a position of great height Wood gives the impression of regarding it almost with the omniscience of a divine eye. It is not an unthreatened world, and we notice very dark patches of shadow in three areas of the picture. But somehow the farmer himself is a figure of light, a positive element despite difficulty and threat.*

THE PAINTING *is a celebration of the American desire to cultivate the wilderness and Wood is suggesting that the wilderness will only remain cultivated at a cost. But he does this with the lightest of touches, so that any moral teaching is swallowed imperceptibly. Spring Turning refers both to the turning of soil and the turning of spring into summer. It is a title of vigorous hope.*

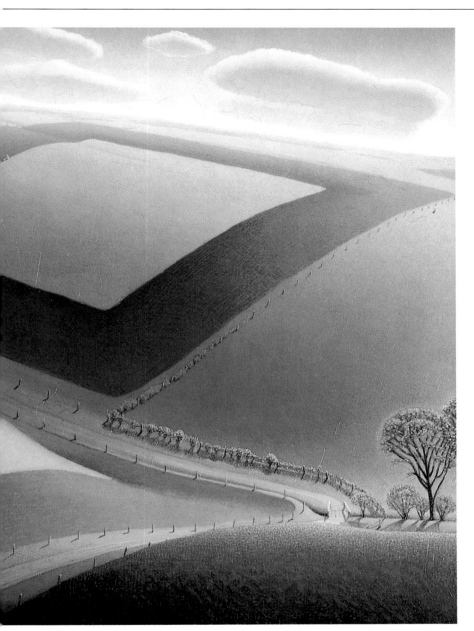

WOOD, GRANT 1892–1942 b. US
SPRING TURNING

GRANT WOOD BELIEVED PASSIONATELY that American artists must find their inspiration in America and free themselves from dependence on the European old masters. He was convinced that every artist should turn to his own region and celebrate it. *Spring Turning* is an extraordinary work. Wood has, of course, massively oversimplified and streamlined this vision of plowing in the gently rounded hills of the Midwest. The great central squares, which the farmer and his horses will circumambulate, nibbling away at the greenery until all is brown plowed land, make glorious abstract patterns. We see three fields in the process of being plowed, and another one up on the far left shoulder in which the plowing is finished, leaving it a mild brown hue. The intensity with which Wood stylizes the work, imposing an intellectual pattern on the scene, makes this landscape both realistic and abstract.

SPRING TURNING,
*1936, oil on masonite,
18 x 40 in (46 x 102 cm),
Reynolda House and Museum of
American Art, North Carolina*

AMERICAN GOTHIC
*1930, oil on beaverboard, 29 x 24½ in
(74 x 62 cm), The Art Institute of Chicago*

This painting is often misunderstood, I think, as almost a caricature of the virtues of the American Midwest. Although it is intended as a tribute, it nevertheless displays an ability to portray the relative unattractiveness of man and daughter. There is a strange subtext also, in the way the father elbows in front of his daughter and holds his pitchfork like a weapon, challenging us with a nonconformist gaze; she takes her rigid position and averts her eyes, possibly with resentment.

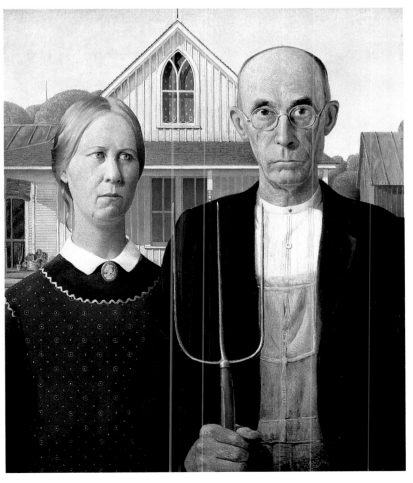

WYETH, ANDREW 1917– b. US
YOUNG BULL

ANDREW WYETH HAS OCCASIONED a good deal of controversy. Many people feel a deep affection for his work, while others regard it as mere illustration. It is difficult not to feel that time will do justice to this artist, whose work seems to me to have a genuine element of greatness. His technique is extraordinary, combining meticulousness and intensity with a melancholy sense of the passing of time and of human fallibility. It is this spiritual undertone that raises the realism of this work to a higher level. There is an almost surrealistic element in the young bull. Every strand of the wire in the gate, every stone in the wall, every pebble on the path, and almost every hair on the bull has been looked at, pondered, and captured in color. We marvel at its strange silence. The young bull stands almost frighteningly still, yet perceptibly it is a creature different in nature from the stone wall and the bare hill, or the white house that is shut away from us, with its closed windows and locked gate. The sense of exclusion is very poignant. It is a strange and haunting painting, which leaves us uncertain as to our reaction and keeps us looking.

YOUNG BULL
*1960, dry brush painting,
20 x 41 in (51 x 105 cm),
Private Collection*

WYETH'S ABILITY TO FOCUS *as with a magnifying glass gives these pictures an extraordinary force. Why has he painted an image in which nothing is happening? There is no narrative and no activity except that of the eye, which can play endlessly over every detail of this scene.*

THE YOUNG BULL, *displayed in his solitude, emphasizes a greater solitude. Behind the rickety gate is an empty world, with one bare tree and a desolate house. Even the sky is utterly cloudless.*

THE LONG SHADOWS *tell us that it is either early morning or late evening. Wyeth values these pools of shade for their sense of mystery, yet his picture seems essentially timeless. No brilliant colors, no activity, no decoration; this is the bleak world of the farm, both austere and noble.*

THE DRIFTER

1964, dry brush painting, 24 x 29 in
(60 x 74 cm), Private Collection

When Wyeth paints a fellow human, the subject very rarely meets our gaze. Here
we encounter a mystery that is all the more evocative for the artist's ability to
portray external details so well. Wyeth has struggled to understand this man –
this drifter – but has been defeated, and humbly offers us the grubby textures of
a coat and jersey and light shining on the noble dome of the man's skull. We are
involved in Wyeth's passion and share his sense of creative frustration.

DIRECTORY OF MUSEUMS AND GALLERIES

ALBRIGHT-KNOX ART GALLERY

Buffalo, New York 14222
Tel: 716-882-8700
http://www.albrightknox.org/

William Baziotes: *White Bird*

ART INSTITUTE OF CHICAGO

111 South Michigan Avenue, Chicago,
Illinois 6063-6110
Tel: 312-443-3600
http://www.artic.edu/aic/

Grant Wood: *American Gothic*

BUTLER INSTITUTE OF AMERICAN ART

524 Wick Avenue, Youngstown, OH 44502
Tel: 330-743-1711
http://www.butlerart.com/

Winslow Homer: *Snap the Whip*

BROOKLYN MUSEUM OF ART, NEW YORK

200 Eastern Parkway, Brooklyn, NY 11238-6052
Tel: 718-638-5000
http://www.brooklynart.org/

Winslow Homer: *The Turtle Pound*, George Inness:
June, Ad Reinhardt: *Untitled (Composition No. 104)*

CARNEGIE MUSEUM OF ART, PITTSBURGH

4400 Forbes Avenue, Pittsburgh, PA 15213-4080
Tel: 412-622-5563
http://www.cmoa.org/

Edward Hicks: *The Peaceable Kingdom*, David Hockney:
Divine, Stuart Davis: *Composition Concrete*, Benjamin
West: *Venus Lamenting the Death of Adonis*

THE DAYTON ART INSTITUTE

456 Belmonte Park North, Dayton, Ohio 45405-4700
Tel: 937-223-5277
http://www.daytonartinstitute.org/

Charles Sheeler: *Stacks in Celebration*

DES MOINES ART CENTER, IOWA

4700 Grand Avenue, Des Moines, Iowa 50312-2099
Tel: 515-277-4405
http://www.artcom.com/museums/

Agnes Martin: *Untitled No. 3*

THE DETROIT INSTITUTE OF ARTS

5200 Woodward Avenue, Detroit, Michigan 48202
Tel: 313-833-7913
http://www.dia.org/

Frederick Edwin Church: *Cotopaxi*, Lyonel Feininger:
Sailing Boats

THE KRANNERT ART MUSEUM AND KINKEAD PAVILION, ILLINOIS

500 East Peabody Drive, Cahmpaign, Illinois 61820
Tel: 217-333-0883
http://www.art.uiuc.edu/kam/

Adolph Gottlieb: *Romanesque Façade*

KUNSTHAUS, ZÜRICH

Zürcher Kunstgesellschaft, Heimplatz 1, CH-8024,
Zürich, Switzerland
Tel: +41 1 251-6765
http://www.kunsthaus.ch/

Cy Twombly: *The Vengeance of Achilles*

LOS ANGELES COUNTY MUSEUM OF MODERN ART

5905 Wilshire Boulevard, Los Angeles, California
90036
Tel: 323-857-4787
http://www.lacma.org/

Mary Cassatt: *Mother About to Wash her Sleepy Child*

THE METROPOLITAN MUSEUM OF ART, NEW YORK

1000 Fifth Avenue, New York, New York 10028-0198
Tel: 212-650-2562
http://www.metmuseum.org/

Charles Demuth: *I Saw The Figure 5 in Gold*, Lee
Krasner: *Rising Green*, Morris Louis: *Tet*, Robert
Rauschenberg: *110 Express*

MUSEO THYSSEN-BORNEMISZA, MADRID

Paseo del Prado, 8, 28014 Madrid, Spain
Tel: +34 91 420-39-44
http://www.offcampus.es/museo.thyssen-
bornemisza/

Arshile Gorky: *Hugging/Good Hope Road II*, Georgia
O'Keefe: *White Iris No.7*, Robert Rauschenberg: *Bed*,
Clifford Still: *Untitled*, Yves Tanguy: *Imaginary Numbers*

MUSEO THYSSEN-BORNEMISZA, SWITZERLAND

Villa Favorita, CH-6976 Castagnola – Lugano
Tel: +41 91 972-1741

Ben Shahn: *Riot on Carol Street*

MUSEUM OF REYNOLDA MUSEUM OF AMERICAN ART

Post Office Box 11765
Winston-Salem, NC 27116
Tel: 336 725-5325
http://www.reynoldahouse.org/

Grant Wood: *Spring Turning*

MUSEUM OF FINE ARTS, BOSTON

295 Huntington Avenue, Boston, Massachusetts
02115-4401
http://www.mfa.org/

John Singer Sargent: *The Daughters of Edward D. Boit;
Mrs Edward D. Boit*

NATIONAL GALLERY OF ART, WASHINGTON, DC

National Gallery of Art, Washington, DC, 20565
Tel: 202-737-4215
http://www.nga.gov/home.htm

Mary Cassatt: *Girl Arranging her Hair*, Thomas Cole:
The Notch of The White Mountains, John Singleton
Copley: *The Three Youngest Daughters of George III*,
Thomas Eakins: *The Biglin Brothers Racing*, Helen
Frankenthaler: *Mountains and Sea*, George Inness:
The Lackawanna Valley, Gilbert Stuart: *The Skater; Mrs
Richard Yates*

NATIONAL GALLERY OF AUSTRALIA, CANBERRA

GPO Box 1150, Canberra ACT 2601
Tel: +61 2 6240-6481
http://www.nga.gov.au/

Jackson Pollock: *New Poles*

NATIONAL GALLERY OF CANADA, OTTAWA

380 Sussex Drive, P.O. Box 427, Station A, Ottawa,
Ontario KIN9N4
Tel: 613-990-1985
http://national.gallery.ca/

Benjamin West: *The Death of General Wolfe*

NORTON SIMON MUSEUM

411 West Colorado Boulevard, Pasadena, CA
91105-1825
Tel: 626-449-6840
http://www.nortonsimon.org/index.html

Agnes Martin: *Leaf in The Wind*

PHILADELPHIA MUSEUM OF ART, PENNSYLVANIA

P.O. Box 7646, Philadelphia, PA 19101-7646
http://www.philamuseum.org/

Marcel Duchamp: *The Bride Stripped Bare by her Bachelors, Even; Nude Descending the Staircase, No. 2*

THE PHILLIPS ART COLLECTION

1600 Twenty-first Street, N.W., Washington, DC 20009-1090
Tel: 202-387-2151
http://www.phillipscollection.org/html/mainmenu.html

Philip Guston: *Native's Return*, Georgia O'Keefe: *Ranchos Church*, Mark Rothko: *Green and Maroon*

SAN FRANCISCO MUSEUM OF MODERN ART

151 Third Street, San Francisco, CA 94103-3159
Tel: 415-357-4000
http://www.sfmoma.org/

Josef Albers: *Study for homage to a Square*, Sam Francis: *Red and Pink*, Robert Mangold: *Red X Within X*, Robert Ryman: *Surface Veil*, Charles Sheeler: *Aerial Gyrations*, Frank Stella: *Khurasan Gate (Variation) 1*, Wayne Thiebaud: *Display Cakes*

STEDELIJK MUSEUM

P.O. Box 75082, 1070 AB Amsterdam, Holland
http://www.stedelijk.nl/

Willem de Kooning: *Rosy-Fingered Dawn at Louse Point*

TATE GALLERY, LONDON

Millbank, London SW1P 4RG
Tel: +44 (0)207 887 8869
http://www.tate.org.uk/

Willem de Kooning: *The Visit*, Sam Francis: *Around the Blues*, Philip Guston: *Black Sea*, David Hockney: *A Bigger Splash*, Jasper Johns: *0 Through 9*, Barnett Newman: *Adam, Moment*, Frank Stella: *Six-Mile Bottom*, Clyfford Still: *1953*, Andy Warhol: *Marilyn Diptych*, James Whistler: *Harmony in Gray and Green: Miss Cicely Alexander; Nocturne: Blue and Gold*

TERRA MUSEUM OF AMERICAN ART, CHICAGO

664 North Michigan Avenue, Chicago, Illinois 60611
Tel: 312-664-3939
http://www.terramuseum.org/

Thomas Cole: *Scene From the Last of the Mohicans*

WHITNEY MUSEUM OF AMERICAN ART, NEW YORK

945 Madison Avenue at Seventy-Fifth Street, New York, NY 10021
Tel: 212-570-3600
http://www.whitney.org/

Charles Demuth: *My Egypt*, Arshile Gorky: *The Artist and His Mother*, Edward Hopper: *Early Sunday Morning, Second Storey Sunlight*, Franz Kline: *Mahoning*

WYETH COLLECTION

P.O. Box 155, Chadds Ford, Pennsylvania 19317
Tel: 610-388-8358

Andrew Wyeth: *Young Bull; The Drifter*

INDEX

PICTURE CREDITS